# SNEAKY EXERCISE

# LESLIE GOLDIN
# SNEAKY EXERCISE

### The excuse-free, sweat-free shape-up program

**World Almanac Publications**
New York, New York

First published in 1986

Distributed in the United States by Ballantine Books, a division of Random House, Inc.

Library of Congress Catalog Card Number 85-51074

Newspaper Enterprise Association ISBN 0-911818-98-7
Ballantine Books ISBN 0-345-33312-8

Printed in the United States of America

World Almanac Publications
Newspaper Enterprise Association
A division of United Media Enterprises
A Scripps Howard company
200 Park Avenue
New York, New York 10166

10 9 8 7 6 5 4 3 2 1

 PHAROS
BOOKS

COVER AND TEXT DESIGN BY NANCY BUMPUS
ILLUSTRATIONS BY CINDY COHEN
COVER PHOTOGRAPHS BY LUCILLE KHORNAK
HAIR AND MAKE UP BY PEGGY ESPOSITO

# CONTENTS

# DEDICATION

To all of my exercise students from whom I have learned as much as I have taught.

And to my family for their closeness and love.

# ACKNOWLEDGEMENTS

I wish to thank:

My editors, Rob Fitz and Daril Bentley, for their great wisdom, patience, and guidance, and for their faith in me.

My art director, Nancy Bumpus, for her creative talents and careful attention to details.

My agent, Peter Miller, who spread his belief in me to others.

My first editor, exercise student, and friend, Joyce Snyder, who encouraged me to reach not only the public, but deeper inside myself.

My photographer, Lucille Khornak, who is as beautiful as she helps me look.

For sharing their tremendous wisdom and expertise:

Julie Batten, fitness journalist and free-lance writer.

David Fleiss, M.D., Coordinator of Resident Education for the Department of Orthopedic Surgery at St. Vincent's Hospital, and staff physician at Doctors and St. Clare's Hospitals in New York City.

Ari Kiev, M.D., Associate Professor of Clinical Psychiatry at Cornell University Medical College and former stress psychiatrist for the U.S. Olympic Sports Council and for Nautilus Sports Training and Medical Fitness Training Centers.

George Maron, Ph.D., exercise physiologist and Executive Director of the Excelsior Health Club in New York City.

Theodore Tyberg, M.D., Clinical Assistant Professor of Medicine, Division of Cardiology, the New York Hospital/Cornell University Medical Center, and attending physician at the New York Hospital.

# INTRODUCTION

## Sneak Preview

Do you remember the last time you had the energy or the inclination to go for a moonlit stroll around the block? Have you been feeling the dull ache of unused muscles as you fall asleep in your favorite chair at 9:30 P.M., hands clasped around a startlingly round middle? Or wondering when climbing the stairs to bed at night got to be so exhausting? If so, *Sneaky Exercise* may be just the answer.

The human body is designed to move. Most of us don't move enough. Cars, elevators, and all kinds of appliances deprive us of adequate physical activity. Our bodies wear out from underuse, not from overuse. We ride trains, buses, and planes to work, or we drive. Once there, our chairs swivel, our telephones keep us glued to the seat, our office computers even make it possible to deliver a memo without standing up. We no longer push lawn mowers; we ride on them. Even our sports have lost a lot of their benefits. It used to be said that a golf game interrupted a good walk; now it merely interrupts a spin in the golf cart. We have so deprived our bodies of adequate physical activity that many of us have lost the ability to move freely. How many of us strain neck muscles just to look over a shoulder, back muscles when picking up a dropped coin? Having lost the grace and ease with which we used to move, we find our balance, stamina, and strength slowly slipping away.

Not very long ago you were healthy if your doctor said that you were disease-free. Today we are learning that being healthy and being fit are not synonymous. The death of James Fixx, bestselling author and running expert, makes the point perfectly clear: Fixx, whose father died at the age of forty-three from a heart attack, started running at age thirty-five, in part to keep history from repeating itself. He died at the age of fifty-three from a massive coronary during his daily ten-mile run along a

country road in Vermont. All of his arteries were blocked. Fixx was obviously fit. He was not, however, healthy. Perhaps with genes like that he was doomed. Even so, running apparently added ten years to his life that he might not otherwise have had. One can't help speculating how many more years might have been added had he not waited until age thirty-five to start moving. Let the fitness boom infect you before something else does, and see a doctor regularly.

Fitness is by no means a fad. It has affected all aspects of our culture, from what we put on in the morning to how we spend our free time and money. If you think it hasn't touched you yet, read on. This book is going to sneak exercise back into your life in much the same way that high-tech gizmos allowed it to sneak out. Take these tips seriously, incorporate them into your life, and let the results catch you by surprise. You'll find that sneaky exercises are easy to follow, require no special clothing, no special time of day, and can be done virtually

**S**o you don't have a tail to wag—move arms and legs double time instead, and you'll turn dog-walking time into workout time.

anywhere. Quite simply, you are going to learn how to keep moving anywhere and everywhere you go. You may in fact find that some of the sneaky exercises I suggest are movements you already do every day quite unconsciously. That's not surprising. In fact, it's the key.

As children, most of us are quite active; after maturity "strikes," inhibitions and proper behavior ensue. When was the last time you spontaneously jumped for joy, broke out into a run, or climbed over something—just for the fun of it? Spend a little time with *Sneaky Exercise* and I guarantee you that the next gloriously rainy day you encounter will have you jumping over puddles—just because you feel like it. It's the feeling like it, not the jumping, that's the feat for most of us.

How often do we see people who haven't exercised regularly for years go out and try to run a mile or two to work off a big meal, a few too many drinks, or a couple of decades of fat? Halfway down the block they're saying, "Oh my God, I can't do this! I give up! I'll never get into shape!" If this is you, you're hardly the only would-be Olympian out there who's sampled and rejected a million different diet-and-exercise programs. Getting started is never the problem; sticking to it is. You must start slowly. That's hard advice to put into action when you finally feel inspired, but take it. It's not only better for you physiologically, but keeping your motivation level high will be a whole lot easier if the task at hand is not obscenely difficult. Make it easy enough so that when you are finished, you will want to go out and do it again as soon as possible. Set realistic goals and attain them. "The more you learn to focus on a goal, the more you develop your capacity to concentrate," says Ari Kiev, M.D., Associate Professor of Clinical Psychiatry at Cornell University Medical College and previously a stress psychologist on the U.S. Olympic Sport Council, "and being able to concentrate is a skill which will translate into other areas of your life." Be aware that the most difficult stage for beginners is the first six to eight weeks. "You spend the first three weeks talking yourself into it and the second three weeks getting into the routine," says George Maron, Ph.D., an exercise physiologist. After that, the results you see become your motivation, and exercise begets exercise.

Did you just find yourself making a mental note about the six to eight week period of beginner's blues? I hope so, because the flip-side to motivation must be knowledge. Learning *how* to reach your goals gets you halfway there. Sheer determination is not enough. Knowledge will give you the confidence you need to keep going, because if you are aware of the pitfalls, you can prepare for them. As you read this and the following chapters, underline or make notes on the parts you find most enlightening.

Sometimes even the best pep talk, however, can't shake that feeling of being just too tired to exercise. Well, hold your head up long enough to get through this paragraph—it just may be a real eye-opener. There are two varieties of fatigue: physical and mental. When you have used your body to the utmost, you are usually blessed with physical fatigue and it feels wonderful. All you need to overcome it is a good night's rest (which you're guaranteed). Mental fatigue can leave you feeling grumpy, unable to concentrate, unable to sleep, unmotivated and unlovable. The best way to overcome it is to change it to physical fatigue through exercise. "You might think of exercise as the mechanism in the control board of an airplane which shows the pilot where he is in relation to the horizon," says Dr. Kiev. "Exercising every day is a way of monitoring yourself—keeping stress levels in check—in much the same way that a pilot monitors his screen." Not exercising would be the equivalent of the pilot's being unaware of anything but the very confined space of a cockpit. Exercise gives us perspective and is a constant reminder that we are in control of moving a highly complex organism, the human body, through space.

Just as exercise is a kind of monitoring device, so is looking at yourself—naked—in a full-length mirror. Become aware of the positives as well as the negatives. Decide what you would like to accomplish and what is possible for you to accomplish, taking into consideration your age, sex, present weight, and medical history. Physiologically, exercise can change more than you might expect it to at any age, regardless of sex. By developing the capacities of your heart and lungs, you will find yourself able to go farther faster. Joints, muscles, ligaments, and tendons will become more elastic and flexible. You

will be developing your body's sense of balance and equilibrium in space. Muscular strength and coordination will improve, helping your body perform movements accurately and gracefully. You will have an improved digestive and excretory system and will be slowing down the aging process.

Although you cannot turn back the clock, you can hold onto what you have and banish some of the ravages of time through exercise. Effective motion helps to eliminate deposits from the joints and the accompanying stiffness and atrophy that we often associate with aging. Exercise improves circulation, which, left alone, tends to grow sluggish as we grow older. It also improves muscular action and body movement. Exercise can correct bad posture and restore firmness to muscles that have become flabby. As long as you have medical approval, it is never too late or too early to start a physical program.

The college-student daughters of my exercise class participants came to an exercise class and found it impossible to keep up with their mothers. Many months of constant and continuous movement enabled the older women to move easily through the program while their daughters struggled. Remember: Youth does not guarantee fitness, and vitality has nothing to do with age.

Far too many older men and women blame the symptoms of inactivity on the number of candles that were blown out on this year's birthday cake. Exercise scientists have begun to recognize the inherently negative effects this attitude can have on an older person trying to stay in shape. "We should all really celebrate two birthdays each year," says Dr. Maron, "one for our biological age, the traditional measurement of our evolution, and another for our physiological age, which depends on how we've taken care of ourselves." Unfortunately, the only part of our bodies for which this does not hold true is our skin. Although it may improve with toning, aging skin loses its underlying layer of fat, which cannot be restored through exercise. However, the positive outlook you get from exercise will make you feel and look years younger than your biological age.

Wherever you may be right this minute, begin sneaking exercise into your life. Sit up straight and instantly you are exercising back and abdominal muscles that were, a few seconds ago, just growing older. Gradually putting my suggestions to work

isn't going to kill you. Not starting at all, will. You are about to embark on a program of muscle-set exercises that are an excellent means of toning and firming muscles in specific parts of the body. This type of exercise has been prescribed for people confined in hospitals and for those on board submarines and aircraft, because little space or actual movement is required. These exercises can help you maintain good posture, support vital organs (much like a corset would), give the body the shape and tone that will make it attractive, and avoid the injuries that are often related to underdeveloped muscles. Key to most of these exercises is the "tuck," which is a posture that facilitates movement. (See page 49.)

Concentrate on the fact that you are worth taking care of, that you are special, and that you want to be the best that you can be. Concentrate fully on every movement so that you feel your muscles stretch or tighten. Each time you flex, you are stronger than the time before. Know whether you are doing an exercise for strength, flexibility, or endurance. The exercises in this book are meant to be done only as many times as you can do them without straining. Be your own instructor; know when to stop and when to forge ahead. Many people find that sneaking exercise into their lives is a good jumping-off point for joining an exercise class or health club, or taking up a new sport. As you read, be selective about which of my suggestions for sneaking healthy habits into your life you find most interesting. Those are the ones that you should incorporate into your daily schedule first. You will find that with time you will be doing more—naturally.

## Before You Begin

It is always advisable to have your doctor's approval before you begin any exercise program. Chances are, however, that exercise is good for whatever ails you. If there is any indication of coronary problems, a stress test will be advised. You'll be asked to pedal a stationary bicycle, row on a stationary rowing machine, or walk on a motor-driven treadmill while an electrocardiogram is taken and your heartbeat, blood pressure, and oxygen intake are monitored. The exercise is made harder every one to

three minutes until the prescribed level of aerobic exertion is reached. Some might say that you are having the test to find out if it is safe for you *not* to exercise.

We rely on our heart muscle to contract some 5,000 times every hour, 120,000 times a day, 44 million times a year, and more than 3 billion times throughout an eighty-year lifespan. Failure of the heart is the leading cause of death in the United States, killing 600,000 of us every year. Most of these deaths are caused by arteriosclerosis, whereby the inner walls of the heart's arteries become thickened with fatty deposits, narrowing the opening through which oxygenated blood can pass. The narrowed artery eventually becomes totally blocked and the part of the heart served by the artery dies. If that happens, you've experienced a heart attack.

Not exercising is just one way to increase your chance of developing cardiovascular illness. Other factors contributing to the disease include poor diet, stress, smoking, excess weight, high blood pres-

*T*ake a sneaky exercise tip from baby: push-pulling everything in sight is a natural.

sure, diabetes, and heredity. The good news is that aerobic exercise—and walking is aerobic, too—can reduce or eliminate all of these factors except, of course, heredity. Exercising vigorously for long periods of time will enable you to respond to physical and emotional demands in life with the minimum of heartbeats and with only a small increase in blood pressure. It will enable muscles to work harder and longer with less effort and stress. The stamina you develop will enable you to go through life putting less strain on the cardiovascular system. Exercise lowers both blood pressure and heart rate, so that the heart requires less oxygen. The exercised body is also better able to handle carbohydrates and less likely to secrete an adrenaline-type chemical in response to emotional stress. This chemical increases the blood's ability to clot in the coronary arteries, a condition which can cause heart attack.

There is also evidence that aerobic exercise can help the body to develop collateral blood vessels in the heart muscle. If true, these collateral arteries would allow the blood to take an alternate route and avoid the blocked areas that cause heart attacks. Another theory suggests that regular vigorous exercise helps to enlarge existing coronary blood vessels, thereby allowing oxygen to get to the heart despite any partial narrowing of the artery. When a person frequently exercises aerobically, he has reduced triglyceride levels and increased HDL (high-density lipoprotein) levels. Reducing triglyceride levels and raising HDL levels are associated with reduced risk of coronary artery disease.

# THE NON-DIET

## What to Consider First

Chances are that if you've flipped to this chapter first, you've been letting outside forces dictate what to put into your mouth for a long time. This book can teach you to decide for yourself what your fork will pick up at the next meal. Each bite you take should be weighed as carefully as a financial investment: some foods are just plain smarter investments than others, depending on the calories and nutritional values they yield.

If the whole phenomenon of calorie counting mystifies you, you're not alone. Building three meals a day out of numbers can seem pointless if you don't understand what you're counting. A calorie is the amount of heat necessary at a pressure of one atmosphere to raise one gram of water one degree centigrade. We measure the energy value of carbohydrates, proteins, and fats in calories. Each pound of fat stored in your body represents about 3,500 calories. This means that if you consume 3,500 calories more than you need to maintain your present weight, you will gain one pound.

Playing with food values becomes fun when you realize how easy it can be to modify your metabolism by increasing or decreasing your energy—or calorie—intake. If you simply reduce your calories by 500 per day, in seven days you should lose one pound (3,500 calories). To determine how many calories you need to maintain your weight each day, multiply your present weight by fifteen. If, for example, you weigh 140 pounds, multiply 140 by fifteen and you'll know that by consuming 2,100 calories per day, you will maintain your weight. If you reduce your intake to 1,600 calories per day, you should automatically lose one pound per week. Although this may not seem like much, one pound per week means fifty-two pounds a year! If you are an extremely inactive person, multiply your weight by twelve instead of fifteen; if you weigh 140 pounds, you need only 1,680 calories per day to maintain your weight. Once you start exercising, however, you'll soon be able to increase your food intake and still lose weight! Also remember that as we grow older our metabolism slows down by about half a percent each year and that past the age of twenty-six our bodies simply do not need as many calories to maintain their ideal weights.

Probably the worst way to spend your daily calorie allotment is to eat sugar. It contains forty-six calories per tablespoon and is lacking in nutritional value. Unfortunately, most Americans consume an average of 128 pounds of sugar each year—a total of about 635 calories of sugar per day. Just like the table sugar that we sprinkle on our cereal and use to sweeten our coffee, many of the prepared foods we eat are laced with sugar. Read labels carefully to see if anything on the list ends with "ose" (fructose, dextrose, lactose), or if corn or maple syrups, brown sugar (which is merely white sugar with molasses), or raw sugars are added. Often on labels boasting low calorie contents, you will find one of the above sugar disguises amid the small print of an ingredients list. Remember also that the ingredient included in greatest proportion appears first on a label; the others are listed in descending order. You'll be surprised to learn how much sugar is in household staples like catsup, peanut butter, bread, cereal, and crackers.

Considering sugar's effect on you may leave a bad taste in your mouth, even if you've got a sweet tooth. Sugar is more like a drug than a food in that it causes hormonal changes. It triggers insulin production, which gives a burst of energy followed quickly by hunger, weakness, moodiness, headache, and fatigue. Unfortunately, the more you allow yourself, the more you'll want, so start curbing your addiction now. If you don't, be forewarned that sugar can contribute to tooth decay, ulcers, arteriosclerosis, heart disease, diabetes, liver and adrenal malfunction, and hypertension. Is it really worth it?

Salt has also been sneaking into our diets in excess in recent decades. It can be found on labels masquerading as sodium alginate, sodium bicarbonate, sodium saccharin, sodium sulfate, sodium propitionate, sodium benzoate, sodium hydroxide, and disodium phosphate. Salad dressings, monosodium glutamate, meat tenderizers, soy sauce, Worcestershire sauce, horseradish, mustard, catsup, barbecue sauce, and instant bouillon are all loaded with sodium. Because salt is used as a preservative in most processed food, it is inevitable that you are consuming too much if you seldom prepare fresh foods yourself. "High levels of sodium can cause your blood pressure to rise and make you feel very anxious," says David Fleiss, M.D. Salt can raise your

blood pressure, cause you to retain fluids, and make you feel anxious and thirsty. Why sabotage your weight-loss program with feelings of anxiety and bloat when you can easily use herbs, spices, onion, garlic, flavoring extracts, and vinegar to flavor food?

Another way to right the effects of a high sodium level is by increasing your calcium intake. Calcium strengthens bones, can decrease blood pressure, and has a calming effect. Unfortunately, in our increasingly weight-conscious society, calcium products like milk are thought of as fattening, and many people have cut back. We also tend to drink and eat foods that deplete what little supply of calcium we already have. "Soda, which is loaded with phosphates, is a prime culprit. When your intestinal system gets bogged down with phosphates, the calcium will bond to them and be excreted from the body. Under normal circumstances, the calcium would have gone to the bones." If you're envisioning a refrigerator full of bland, white, stick-to-your-tongue milk products, and feeling less than enthusiastic, *relax.* "Taking either 500 milligrams of calcium carbonate or one gram of calcium gluconate three times a day with each meal is an inexpensive

way of getting all the calcium you need," Dr. Fleiss recommends. See how easy sneaking the right stuff into your diet can be once you know how?

What follows is a long list of tips on everything from how to find low-calorie foods when eating on the run to keeping your spirits up (and your taste buds happy) when everyone else at the table is eating tortellini in cream sauce. You'll learn what your best food bets are in terms of calories, taste, availability—at home and in restaurants—and quantity. You can eat virtually anything you want and stay skinny; it's the amount you eat that counts. Some of my suggestions may seem obvious to you; others will be just the advice you will need to overcome the bad habits that have sabotaged every attempt you've ever made at getting in shape. I've also included special sections labeled Mindworks to help you exercise your positive-thinking mechanism. Put into practice a new tip every day and you will find your attitude about food changing. Suddenly, you'll be thinking like a "normal eater" rather than a "dieter." *That's* the real secret behind every bikini-clad bottom or muscular stomach you've envied, so don't delay working these tips into your life!

## Mindworks

Don't think in terms of forever. Just think that you are going to be good to your body during this meal, today. It is hard to think in terms of forever.

Do what is best for *you*. No one else really cares that much about what you do and do not eat.

Try thinking of not eating this minute. Put eating off until it is time for a regular meal.

You are in charge of your eating, and ultimately it will be your fault if you give in to the temptations presented to you in certain situations. The battle of the bulge is your own battle and only you can be the enemy. You can also be your greatest ally.

## Behaving Like a Skinny Person

- Go to lunch with a slim friend. Watch how and what he or she eats. Observe the way the person moves and relates to food. Try to incorporate those healthy eating habits into your life.

- Don't let other people tell you what to eat.

- When using a spread, apply it thinly enough to see through. Allow syrup to dribble rather than pour; scrape as much butter as you can off of everything you spread it on; and do the same with jams and jellies. A smear tastes as good as a gob.

- Try to fill your mealtime with lots of pleasant, lengthy conversation. The more you talk, the less you can eat.

- Refine your tastes. Learn to appreciate the flavors, aromas, textures, and colors in a meal. The scent of food can give you as much pleasure as the taste.

- Play with your food. Take time cutting it into various shapes and sizes.

- Be aware that it takes your stomach fifteen to twenty minutes to send the message to your brain that it has been satisfied. Eating slowly allows the message to reach your brain before you are finished, which makes you think you are full faster than if you were to eat quickly.

- Let the picky child in you emerge. Eat only your

favorite part of a particular item. If you like the crust of the bread, don't eat the center.

- Trick yourself out of eating. If you want a piece of bread with your dinner, tell yourself that you may have it at the end of the meal. By that time you will be satisfied enough that you will either no longer want the bread, or you will at least have enough willpower to consciously tell yourself not to eat it.

- Take pleasure in eating foods that will help create a beautiful, healthy you.

- Eat what you love even if that means eating the same thing every day. A set eating program that adds up the right number of calories can keep you on track in moments of weakness.

- Try to eat on a small plate, using small utensils: dessert spoons and cocktail forks can help slow you down. Try eating with chopsticks.

- Don't keep anything in your house that you can't imagine your skinny friend eating.

- At home, put only as much food on your plate as you plan to eat.

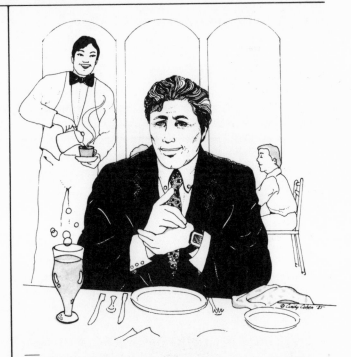

*Pushing hand against hand can whisk away tension, build arm and chest muscles, as well as keep the lid on touchy dinner conversations.*

- When you are given candy or food as a gift, do not open up the package. Instead, be generous to yourself and others by giving it away immediately, or by sharing the box with others.

- Eat only when you are sitting. Once at the table, make a real ritual out of unfolding your napkin, sipping your water, and picking up and putting down your utensils with each bite. Try to stall the first mouthful as long as possible and when the time comes to eat, make it a long, lingering, lovely process.

- Try giving away half of your lunch. Always offer the first half and eat the remaining half, or you may find that by waiting to offer the second half to a friend you will eat the whole thing yourself.

- When you are finished eating, try to get away from the table as quickly as possible. Don't linger; you'll only be tempting yourself to eat more food.

- Try to place a mirror near where you sit so that you can watch yourself eating. Make sure that you see the person with the eating habits you admire sitting there.

- Never put a mouthful of food into your mouth until you have swallowed the one that preceded it.

- Eat large amounts of low-calorie foods when emotional tension or hunger pangs threaten to throw you off balance.

- Always have a low-calorie snack before dinner to get rid of hunger pangs and help you resist overeating at dinner.

- Try eating six to eight mini-meals a day of about 150 to 200 calories each, rather than three big meals, and you will never feel deprived or hungry.

- A great way to get several snacks during the day without adding calories is to save parts of your meal to eat later.

## Mindworks

If you are about to reach for a "no-no" snack, *stop*, take a deep breath, and move on.

Think through any situation in which you might be

encouraged to eat unnecessary food. Preplan what and how much you will eat. Preplan what you will say to people who try to sabotage your attempts to lose weight.

Think swimsuits.

Think confidence.

Think self-esteem.

# Sneaky Snacking

- Have poached eggs when others are having scrambled or fried; puffed rice instead of flake cereals; club steak instead of meat loaf; pretzels or popcorn instead of potato chips; bouillon instead of cream soups; seeds that you have to hull instead of nuts that are easy to eat by the handful.
- Raw vegetables with a low-calorie dip are a wonderful snack.
- Use dietetic jams, jellies, syrups, and sodas.
- Lettuce is a fabulous food. It is not fattening and it makes you feel full. Stuff your salads with lettuce and you will feel stuffed.
- Shrimp, crudite, olives, and small amounts of cheese are the best hors d'oeuvres to eat. Avoid elegant concoctions made with cream cheese, sour cream, or mayonnaise.
- If you need to feel the sense of chewing, eat a raw carrot or chew sugarless gum.
- Cream in your coffee is a waste of calories. Dry milks and skim milks are good substitutes.
- If you've got to have dessert, go for fresh fruits, homemade sherbets, plain yogurt with fresh fruit, homemade puddings or muffins.
- When you desire something sweet, suck on a lemon or brush your teeth. Both of these things will take away your desire for the sweet taste.
- Skim milk with a low-calorie syrup or a low-calorie milkshake mix are great ways to sneak milk into your diet and get the feeling that you are having something forbidden.
- Sugar-free gelatin desserts are wonderful. Top them with a spoonful of non-dairy whipped top-

ping or some fresh fruit and you have a very satisfying, very sweet treat that doesn't contain a zillion calories.

- Try garnishing your plate with lots of lemon wedges, parsley, mushrooms, and tomatoes to make your small portion look large.
- The best bets in vegetables are lettuce, bean sprouts, broccoli, cauliflower, cabbage, radishes, spinach, mushrooms, peppers, and string beans. Next best are tomatoes, eggplant, and carrots. The most fattening group includes artichokes, avocados, onions, and squash.
- Cut back on fatty, high-calorie meats like pork, lamb, and beef. Fish and poultry are lower in calories and contain much less fat.
- A good way to ease the tensions of a long day and avoid grabbing the wrong thing after work and before dinner is to plan appropriate snacks, such as apple slices spread with peanut butter, a few seeds and raisins, a cup of hot bouillon, or a few crackers spread thinly with cheese.
- Try buying or making fresh-fruit Popsicles. They are low in calories and are delicious.

- Try making a healthy, filling snack of vegetable-filled broth.
- An English muffin with a slice of tomato, some oregano, garlic, and grated cheese makes a great "sneaky" pizza!
- A half cup of orange juice is 55 calories; a half cup of tomato juice is only 25 calories.
- A slice of pumpkin pie is far preferable to a slice of pecan pie of equal size, because, believe it or not, you save 215 calories.
- Eating water-packed instead of oil-packed tuna is a calorie bargain.
- Frosted chocolate cake is far more fattening than an equivalent slice of pound cake.

## Mindworks

In time, your taste will adjust and you will find that sugared sodas taste too sweet, whole milk tastes too thick, and ice cream with fat tastes too rich.

When tempted to eat unnecessary food, look at

the item and ask yourself if you are going to let that little thing come between you and your goal of being slim and happy.

When all else fails, stand in front of a full-length mirror (preferably without clothes on) and remind yourself that you still have weight to lose, and that smaller portions mean a smaller you.

## Alcohol

- Be sure to control your intake of alcohol. Not only is alcohol fattening, it also inhibits your ability to control your eating.
- When ordering a drink, remember that wine is lower in calories than hard liquor, and a wine spritzer limits the amount of wine that can be fit into the glass. Also remember that mixed drinks

*Instead of picking up an alcoholic beverage, which is fattening and inhibits your ability to control your appetite, loosen up with a group of friends. Try to develop a social life around activities other than eating and drinking.*

are much lower in calories when served on the rocks or mixed with water.

- If you don't want to drink, or want something very light, you might try either mineral water with a twist or a fruit juice spritzer.
- Diluting liquor with water slows down the rate at which your body absorbs it; mixing liquor with a carbonated beverage speeds up the absorption rate.

# Mindworks

Attaining and maintaining your ideal weight have never been and will not be easy, but you must have a positive attitude. Getting control of your food intake is the first and critical step. An enjoyable meal from which you can walk away feeling satisfied, knowing that you have nourished your body in a loving and controlled way, is far more satisfying than overeating and punishing yourself.

If at times you feel discouraged, or doubtful, write your feelings down, or share them with a friend who supports you in your goal. Perseverance pays off. Don't give up.

# Water

- It is still good advice to drink plenty of water while dieting. Water not only makes you feel full, but it helps keep the body in balance.
- Use tricks to fool yourself into thinking that you are consuming more than you are. For example, always mix juices with water.
- Drink a glass of water before each meal to fill you up, and sip some all day. It will help you make it to the next meal or snack time without feeling famished.
- Our bodies are made up of sixty percent water, which is used to remove toxins and mucus, and keep waste materials flowing. It increases the volume of blood to help transport oxygen and nutrients more efficiently.
- One glass a day is not enough. Aim for eight to ten eight-ounce glasses every day.

- It is not a substitute to drink diet sodas, coffee, or juices. Only pure water will do, and that includes spring water and low-sodium sparkling waters.

## Mindworks

Mental practicing: before you get out of bed, close your eyes and try to relax your body and mind completely; then think about the day to come. Fantasize and picture yourself getting up and eating a healthful, small breakfast, and continuing through the day eating completely in control, eating only the foods that you have allowed yourself. Do this every night before you fall asleep, on your way to work—even every so often while you're at work. Before you know it, your fantasy will become a reality.

## The Home Plate

- Always serve from the kitchen, loading each person's plate with his or her portion. Never serve the food family style. Don't place large platters in the center of the table, because this allows you too much leeway with how much to take for yourself, and makes it too easy to go back for seconds.

- When dinner is through, make sure the extra food is immediately placed in containers in the freezer so that you cannot go back and eat all the leftovers.

- Try to balance the meals so that each one contains only one item that is calorie laden. For example, if you are having beef for dinner, have a steamed green vegetable, a dry salad, and only fruit for dessert. If your main dish is fish, then you might feel comfortable having a baked potato, and a little bit of salad dressing.

- Serve yourself on a salad plate instead of one of the dinner plates you set down in front of everyone else. If the dishes all have the same pattern, usually no one will notice that yours is slightly smaller. It makes the most health sense to use the dinner plate for salad.

- Turn your family on to the wonderful taste of

sherbet or ice milk, and refuse to buy ice cream (less temptation for you and a good way to make sure your family doesn't develop a lifelong habit of craving sweets).

# Mindworks

Eat to live, don't live to eat.

Depending on which works best for you, keep either a fat or a skinny picture of yourself pasted to the refrigerator. This old-but-effective trick can be responsible for keeping the refrigerator door shut tight time and time again.

You might also try keeping a list of ten things you have been meaning to do pasted to the refrigerator door. When you are about to eat out of boredom, take action instead.

If whatever you put on the refrigerator door becomes so familiar that you stop seeing it there, switch to a new photo or list that grabs your attention again.

# Cooking Hints

- Refrigerate soup stocks, stews, meat drippings, and sauces so that you can remove the hardened fat from the surface before reheating them to serve.

- When the recipe calls for frying or sauteing, bake, broil, poach, or steam instead. Broiling meat allows the fat to drip out.

- When you prepare sausage or hot dogs, always puncture the outside with a fork and boil the meat in water so that the fat is able to escape. Then, brown it in a fat-free skillet for flavor and taste.

- Non-stick sprays and coatings help you cook without grease and added calories.

- Always cut away the bulk of fat from meat before cooking. Remove the skin and fatty pads under the skin from poultry. Pulling it off afterwards is not as good because the meat will have absorbed some of the fat in cooking.

- Avoid olive oil because it is full of saturated fats. If you must use oils, use safflower, sunflower seed,

corn, soybean, or sesame seed oil; they are lower in saturated fats.

- Habitually use imitation instead of real butter and plain yogurt instead of sour cream or mayonnaise.

- Learn the cuisine of foreign countries. Indian and Turkish cuisines use a lot of yogurt and fresh vegetables, and are less fattening than French and Italian dishes.

- Buy cookbooks with low-calorie recipes and read them religiously. Use the recipes and, if you don't tell anyone, no one will notice.

- Use leaner, less expensive cuts of meat and tenderize them by soaking them in fat-free marinades, or by cooking them longer at a lower temperature.

- You can cut calories by using winter squash instead of sweet potatoes. You will save about 200 calories in just a half cup.

- Cut some of the calories from meatballs by using ground turkey, beans, or soybean meal as a substitute for red meat. You will be eating approximately one quarter of the cholesterol and half to one quarter of the calories.

- Learn about the use of herbs and spices so that you can add flavor and variety without adding calories. Variety adds spice to life and spice adds variety to meals.

- It might be wise for you to bake muffins at home so that you know what ingredients have gone into them and how many calories they contain. Making your own frozen dinners is a good idea for the same reason.

- To reduce the fat content of bacon, be sure to drain and blot it thoroughly on a paper towel. To reduce calories even further, eat two slices of Canadian bacon, which contain 30 calories, instead of two slices of fried American bacon, which contain 100 calories.

- Vinegar, soy sauce, lemon juice, and unsweetened tomato sauces are all good bases for dressings and sauces that don't require oil.

- To make imitation cream soups, use skim milk, dry milk, or water as the recipe requires. You can thicken soup by adding a tablespoon of flour.

- When recipes call for eggs, use one whole egg and just the whites from the remaining eggs. It is the yolk of the egg that contains the cholesterol and the calories. You can also use two egg whites as a substitute for one whole egg.

- Use soy sauce, Worcestershire sauce, or chicken broth to brown mushrooms, onions, or other vegetables to avoid using fats.

- Vanilla and other extracts, and fruit juices are good sugar substitutes.

## Mindworks

Plan your food intake on paper, then check off each food to show you have stuck with your plan.

Always remember to keep the emphasis on long-term, not immediate, results.

## Grocery Shopping

The more carefully you shop, the more likely you are to buy the foods that will keep you and your family trim and healthy. The following are some useful hints.

- The psychological need that food fills is tremendous. Food manufacturers are aware of this and therefore supermarket shelves are stocked with thousands of attractively packaged foods that are unnecessary and low in nutrition.

- Stock up on nutritious convenience foods so that you aren't tempted to nibble indiscriminately. Suggestions: canned goods like water-packed tuna, crab meat, low-calorie soups, water-packed fruits; frozen vegetables; shrimp cocktails; fish fillets; diet breakfast or snack bars; unsweetened vegetable and fruit juices; and vitamin-fortified cereals.

- To limit your consumption of fat, you should remember that prime meat usually has the highest fat content. When choosing leaner cuts of meat in beef, look for flank, round, and rump. In lamb, look for leg and loin. In veal, all cuts are quite lean, and in pork, all cuts are quite fatty.

- Before you go to the supermarket have a long

talk with yourself and a mini-meal. Condition your mind in such a way that you buy only foods that are good for you.

- Make a point of buying your meat from a butcher who will trim away the excess fat, so that you aren't tempted to cook with the skin or fat.

- When buying dairy products, stick to low-fat or fat-free varieties. These give you more protein and less fat.

- Shop the low-calorie food department in your grocery store. There you'll be able to find a wide variety of packaged foods—including cheeses, sour creams, cottage cheese, jams, and dressings—with reduced calories.

- Always go to the supermarket with a grocery list, and don't buy anything that isn't on it.

- Just because something says "dietetic" does not mean that it is low in calories. Sometimes it merely means that the product has reduced sugar or salt quantities. This is also true for low-fat or fat-free labels; low-fat yogurt sweetened with fruit preserves can contain about 250 calories, whereas low-fat plain yogurt has only about 90 calories.

- When buying dairy products, the word "imitation" may not be bad. For example, "imitation" mayonnaise, sour cream, and cream cheese can be very tasty.

## Mindworks

If you are the type of person who follows rules well, eat only at pre-specified times of the day. You will get to know your eating schedule, and your "appetite alarm" will go off accordingly.

Know without a doubt how much you can eat daily and still lose or maintain weight. Keep daily records until your behavior becomes automatic.

## Eating on the Run

Eating on the run is never the best way, but if you must, here are some tips on minimizing calories and maximizing nutrition.

- Tea, coffee, skim milk, low-calorie sodas, and water are available everywhere. Fill up on them.

- When traveling, carry good food with you in the car, bus, or train so you aren't at the mercy of fast-food shops and vending machines.

- If you are forced to eat out of a vending machine, look for those that offer dry roasted nuts, raisins, cheese, or peanut butter crackers—if not particularly low-calorie, they are nutritious.

- If there are no diet sodas available, don't opt for a cola—stick to water.

- If your weakness is chips, it is not hard to find small bags that weigh in at about 200 calories.

- Delis and small grocery stores are more apt to have small, snack-size packages of food than will the larger supermarkets.

- In a pinch, a hot dog from a vendor can be a

*Turn a mess into a stretch: bend your knees slightly and bend from the hip, rather than stooping from the back. The rush of blood to the upper body will perk up an idling energy level more than coffee will.*

good source of protein. Try to avoid the sauerkraut; just use a little mustard, and throw away the bread as you eat. These meats are fatty and loaded with sodium; however, they can appease your hunger for up to three hours.

- Avoid fast-food burger and fried-chicken chains, as this food is high in calories and fat but low in nutrition. Instead, have a slice of pizza. Pizza is a good source of protein and vitamins, particularly vitamin C. A slice has about 200 calories. Use napkins to blot off excess oil.

- If you have no choice but to stop in a fast-food chain, have the fish sandwich, remove the bread and the breading, and try to eat just the fish. Ask them to exclude their special sauces.

- Bringing a snack or breakfast bar from home in the morning is safer than stopping off for coffee and donuts.

## Mindworks

In addition to keeping a "fat" or "skinny" picture of yourself on the refrigerator door, carry one in your wallet where you keep your paper money. This may keep you from needlessly spending your money on snacks during the day.

Make plans—especially on weekends.

## Brown-Bagging It

- Bringing meals, mini-meals, or snacks with you to the office, shopping, or on any kind of a trip can be a tremendous way to control otherwise poor eating habits.

- Plain cottage cheese can be bland and boring. However, try adding limited amounts of any of the following: nuts, fresh pineapple, apple, raisins, seeds, dried fruits, scallions, chives, green olives, radishes, black olives. Top with various extracts and seasonings.

- If you pack frozen shrimp or crabmeat cocktail in the morning, by noon it will be thawed, cool, and delicious. Eat this with a slice of bread or crackers, and finish with a piece of fruit to balance the meal.

*D on't sit around at home with nothing to do, but eat. Make plans, especially on weekends. Take your mind off food by going to the beach, and enjoying the sun and the surf instead.*

- A delicious brown-bag salad can be made the night before by cutting up your favorite vegetables and placing them in a sealable plastic container. The next day take it to work with a packet of prepared diet salad juice, melba toast, a small box of raisins, a pill bottle filled with freeze-dried chives, oregano, paprika, or curry powder, or little bags of dried fruit and nuts. When lunchtime comes, every bite will be a different taste treat, depending on how you use your supply of "additives."

- It is worthwhile for the brown-bagger to invest in a thermos, so that food may be kept hot or cold in transit. Also, many offices now have refrigerators and microwave ovens available—make use of them!

- Canned soups are great if you have the necessary elements to heat them. If not, pack a cold luscious treat like gazpacho or avocado soup.

- A boiled egg is wonderful because it comes in its own wrapper. You can adorn it with a little garlic powder, mustard, or salad dressing.

- Teas that come prepackaged in one-ounce wrappings are good hunger-pang stoppers to carry with you at all times.

- Adding any flavor of diet gelatin to farmer cheese, plain yogurt, or cottage cheese makes a delicious dairy treat.

- Every now and then splurge at the supermarket and allow yourself the luxury of an imported Spanish melon, fresh mushrooms, kiwi fruit, or papaya for lunch.

- Fruit salad that you've prepared from fresh fruits the night before is wonderful at lunchtime with a yogurt and vanilla extract dressing on the side.

- When brown-bagging yogurt, use the plain variety and mix in fruits, berries, instant coffee, or vanilla extract for flavoring.

## Mindworks

Try to develop your social life around things other than food.

Remember: you are responsible for the first uncontrolled, unthinking, self-indulgent bite. Don't take it!

Realize that learning to stop when you are full is a goal in itself.

## Restaurant-Hopping

Restaurants are a dangerous place for the dieter. Here are ways to enjoy the experience and minimize the damage.

- Always eat a small meal about a half hour before you go out to any restaurant so you don't attack the bread basket when you get there.

- Ordering an appetizer or two and a salad can be very satisfying and fill your need to taste a variety of foods.

- Avoid restaurants that feature all-you-can-eat buffets.

- You can and should control what you eat in res-

taurants, so don't be intimidated by the waiters—they are there to serve *you*.

- Plan ahead: decide beforehand what you are going to eat, so there is no need for you to look at the menu and be tempted into ordering something fattening.

- Choose your restaurants carefully. Avoid restaurants that have a menu limited to high-calorie, creamy foods.

- Adopt the attitude that food is not the important factor of the evening when dining out. Instead, concentrate on the company, the surroundings, the table setting, or anything else that strikes your fancy.

- There is no need to mention to everybody at the table, to the hat-check girl, and to the waiter that you are on a diet. This just causes people to snicker or tease, or to try to entice you into eating. If you are worried about being challenged about not eating something, say you are allergic. Tell the waiter that you cannot have butter or mayonnaise because it will make you sick.

- Order less than you want. You can always order more; but if it is there, you will feel compelled to eat it.

- Don't feel that you have to finish everything on your plate because you are paying a premium price for it. By eating, you will pay for it twice, once from your pocketbook and once on the scale.

- Use your waiter wisely. For example, don't be afraid to ask how particular entrees have been prepared (fried, poached, broiled), and get in the good habit of making special requests. Ask for vegetables that are steamed, meat and poultry prepared without oil or butter, and *fresh* (not canned) fruit. Specify that you would like the gravy, sauce, or dressing on the side.

- Sharing a meal is always a good way to watch food intake: half the food, half the calories. With an appetizer, half of a single meal is often enough.

- If the waiter seems reluctant or put off by your special requests, make sure he knows that you are

the customer. It is your money, your peace of mind, and your hips that are important. If he tells you that substitutions are not allowed, tell him you will pay extra for the privilege. It's worth it.

- Just because certain things are included free with your meal does not mean that you have to eat them. To avoid temptation, ask the waiter not to put them on your plate. For example, if your hamburger comes with french fries and cole slaw, ask the waiter to give you a little extra lettuce and tomato instead.

- Never order *creamed* anything!

- If you are served something that you do not want to eat, make it uneatable by pouring too much salt, sugar, or pepper on it. Mashed potatoes with sugar on them are awful.

- Ask the waiter to serve the meal slowly, with pauses between the courses.

- Don't be embarrassed to send back food that is

*P*arty-pooped? Pick up your spirits and energize with this exercise: pull a resisting arm closer to your body.

not prepared the way you ask for it. If you ask for your fish "broiled dry with no butter" and it comes drowned in grease, send it back!

- If you are feeling deprived, yet in control, ask someone else at the table (preferably someone you know well) for a bite of what they are eating. It's never as good as it looks.

- Try to eat less than half your portion. Take the other half home for lunch the next day.

- Broiled, baked, roasted, poached, or steamed foods are healthiest and best when watching calories. Avoid *fried* anything!

- Remember that you will leave the restaurant angry with yourself, the company you are with, and the world if you have eaten more than you planned to eat. You have to remain in control; it is nobody else's job.

- When eating out Italian-style, antipasto and a salad, poached salmon, broiled chicken, veal marsala, broiled veal a la limone, Neapolitano (a cold seafood salad), and pasta primavera are your best bets. Avoid anything Francese (butter, but-

ter, butter) and beware of marinara sauce (one half cup of this tomato wine sauce contains 100 calories).

- When eating Chinese food, steamed vegetables with either shrimp or chicken are your best bets. Order everything without rice and without sauce. You should also stay far away from the noodles which waiters almost always put down in the middle of the table for everyone to share. Take it easy with the fortune cookies and ask someone else at the table to open and read your fortune.

## Mindworks

Concentrate on your clothing and your grooming daily—even if at first it seems that you're playing dress-up. You'll soon get used to and like your more pulled-together look as you become more aware of your body with good eating habits and exercise.

Don't eat too much. Keep moving!

What you do in five days is unimportant; what you do with your life is what counts.

## Energizing Recipes

Try these low-calorie, nutritional recipes for the shape you want without sacrificing your taste buds.

- Sneak the calories out of cole slaw by shredding up red and white cabbage and mixing it with yogurt, a dash of lemon, sweetener, mustard, and scallions.

- Make yourself a cucumber boat by slicing one in half lengthwise, scooping out the seeds, and filling it with your favorite tuna salad, chicken salad, egg salad, cottage cheese, or yogurt creations.

- Create a yogurt sundae by using a beautiful ice cream sundae dish and filling it with your favorite fruits, plain yogurt, and other adornments.

- A "yoga-loupe" can be created by cutting a cantaloupe in half and filling it with your favorite yogurt mixture.

- Water-packed tuna fish can be baked into casseroles with frozen or fresh vegetables of any variety, oil- and sugar-free tomato sauce, and any spices you might choose.

- Broiled tuna on an English muffin with a slice of tomato, a sprinkle of grated cheese, and some oregano makes a lovely treat.

- Mix low-fat plain yogurt with Dijon mustard, dill, and a bit of low-calorie sweetener or fruit juice. If you use a low-calorie sweetener, you get a thick dressing that is wonderful on salad or baked potatoes. By adding fruit juice you get a thin dressing, wonderful for pouring on both green salads and cold pasta.

- Sneak the calories out of French dressing by mixing one cup of tomato juice and a quarter cup of vinegar or lemon juice, some chopped onions, garlic, pepper, or other seasonings, such as mustard, chili, bay leaves, Worcestershire sauce, or Tabasco sauce.

- Cut up your favorite fruit and stick it in the freezer. Sucking on a piece of frozen fruit will

ward off the munchies and make your mouth think it's gotten hold of some ice cream!

- Make yourself an eggplant cheeseburger by melting some diet cheese on top of a thick slice of eggplant that you have lightly fried.

- Clean out half of a green pepper and fill it with yogurt flavored with onion soup mix.

- Sneaky whipped cream can be made by mixing two cups of evaporated skim milk with one teaspoon of lemon juice. If you are not opposed to them, you can add low-calorie sweeteners. Chill and whip the mixture until thick.

- Sneaking milkshakes into your healthful low-calorie diet is easy by using powdered skim milk, carob powder, sweetener, and lots of ice whipped up in the blender. Change the flavor by adding strawberries, bananas, or other favorite fruits.

- A delicious white sauce can be made by mixing one tablespoon of flour with one cup of skimmed milk in a saucepan.

- Stuffing a tomato with egg, tuna, or chicken salad that you have made with diet dressing is a magnificent creation. Again, make your salad with mustard or yogurt instead of mayonnaise.

- An "un-sandwich" can be made by wrapping up cold slices of chicken, lean beef, turkey, or cheese in lettuce.

- *Carrot salad*: mix one shredded carrot with cinnamon, a few raisins, a touch of apple juice, and a bit of low-calorie sweetener.

- *Waldorf salad*: spoon one cup of plain, tangy yogurt onto a bed of greens and top with diced apple, a handful of sprouts, or celery hearts.

- Cover a chicken breast with a mixture of curry powder, crushed garlic, onion salt, and fresh pepper, then broil it, adding green pepper rings and scallions or shallots when halfway cooked.

- Bean sprouts sauted with crushed garlic cubes, sliced mushrooms, diced scallions, and soy sauce make a delicious sauce for chopped steak or boiled chicken.

- Saute shrimp until pink and serve with slivered almonds and chives.

- Take a huge mushroom cap and fill it with cottage cheese, then sprinkle it with paprika or dill.

- Roll half an ounce of juicy ham around some farmer cheese and hold it together with a toothpick.

- Make a cucumber sandwich by placing an ounce of cottage cheese or imitation cream cheese on a slice of cucumber, sprinkle with caraway seeds, put another cucumber slice on top, and hold the combination together with a toothpick.

- *Cranberry mold*: use one three-ounce package of raspberry-flavored gelatin, two cups of whole cranberry sauce, a half cup of sliced celery, one tablespoon of fresh grated orange peel, and two tablespoons of prepared orange peel. In a small bowl, dissolve the gelatin in boiling water, mix in cranberry sauce, celery, and orange peel. Stir. Pour into three- or four-cup molds and chill for about two hours, until firm.

- *Orange delight*: dissolve orange gelatin with one cup of boiling water. Place the mixture in the blender and add eight ice cubes, one at a time, at low speed. Whip at medium- to high-speed for one minute. You can either drink this milkshake or refrigerate until jellied.

- *Gelatin supreme*: prepare using the quick-set method found on the back of any gelatin package, using six to eight ice cubes. Chill for half an hour, then fold in one cup of dietetic pears and twelve miniature marshmallows. You will have four three-quarter cup servings, 40 calories each.

- *Fruit passion*: prepare one three-ounce package of raspberry- or cherry-flavored dietetic gelatin. Chill until slightly thickened and then beat in one cup of plain yogurt until light and fluffy. This makes eight half-cup servings, 20 calories each.

## Mindworks

Decide your ideal weight. Then continually repeat to yourself "I will eat only what I need to maintain that weight." Do this many times a day. Your body

knows what it needs. Let your subconscious help you create the body you want to have.

Buy a beautiful new something-to-wear that is too small for you at this time. It will be a constant reminder of where you are headed. Try it on every few days so that you don't forget your goal.

Join a weight-control group. The help, advice, and camaraderie of these groups can give you just the edge you need to make it.

## Pitfalls

There are any number of gremlins ready to tempt you and to trip you up. You can avoid overeating and eating poorly by following these important points.

*K eep the goal of a slimmer, fitter you in mind. Buy a beautiful, new something-to-wear that is too small for you now. Picture yourself in it this summer or on your next vacation, after you've realized your goal.*

- More important than what number shows up on the scale is how you feel. The scale can be deceiving in that it can show no weight loss due to water retention, even though there may be some actual fat loss. Try not to weigh yourself any more than once a week, and always weigh yourself at the same time of day. Personally, I avoid the scale completely. If you've lost weight, you think "yeah! I can eat!" If you haven't you think "why bother?"

- Try to become aware of the emotions that send you to the refrigerator. Are you most often tense when you eat? Are you overcome by a fear of success after a long period of being in control? Do you eat when you are sad? In order to modify your bad habits, you must first recognize them. Tune into yourself now.

- Have an emergency plan already thought out ahead of time for those moments when you feel yourself about to binge. Running in place for five minutes, walking briskly, jumping in the shower are all ways to renew your body sense and get you back in touch with your goals.

- Don't eat because you have nothing else to do. Food will not diminish your isolation.

- Remember that vegetables *do* have calories, and that you should not eat them in unlimited quantities.

- Be aware of the external forces affecting your appetite. Watch how what you see, smell, hear about, and talk about in terms of food affects your hunger response.

- Caffeine can stimulate your appetite and sabotage your weight loss program, so set yourself a limit.

- The business meal is anything but a calorie deal. You usually feel obligated to keep up with the people with whom you are dining. Often, because money is not out-of-pocket, food abounds. Use all the sneaky eating and restaurant tips you can think of to overcome this pitfall.

- Never stand around in the kitchen waiting for dinner to cook. The pre-dinner nibbler is often sitting down to a second meal by the time dinner gets put on the table.

- Don't keep food no-no's in the house. Out-of-sight means out-of-mind (but if they're there, they'll wind up in your mouth before you know it).

- Going someplace where you'd rather not be or going with someone you'd rather not be with might make you uncomfortable and cause you to eat more than you normally would. Be prepared with excuses that will help you turn down such situations.

- Do not fast. When you restrict your calorie intake that severely, your body is quick to slow down your metabolism and run on low gear. You won't be burning all the calories you might have burned with a low-calorie, balanced food program. Also, your body will remain in low gear for some time after you've stopped the fast, which will cause you to gain weight very quickly when you do start eating again.

- Keep your body warm (by wearing extra clothing and by keeping the heat turned up through drinking or eating warm foods); keep it well oxygenated (through exercise) and well rested. Low body temperature, not enough oxygen being circulated, and high fatigue can send cues to your brain that you are low on energy and need more fuel. Don't be fooled by false hunger pangs.

- Studies have shown that the most successful weight loss is about two pounds a week at most. Patience can be your biggest ally in this game.

# TYPES OF EXERCISE

# Now's the Time

Sitting down reading this book all day may actually prove more painful for you than running three miles. When we don't work our muscles enough to squeeze naturally occurring, pain-provoking toxins out of them, we suffer discomfort like that of an athlete who has overtrained and overloaded his muscles with toxins that can't be purged by the body fast enough. In both cases, too many toxins—from either too little or too much activity—make us feel aches and pains we haven't felt since our last adolescent growth spurt. But stay in your seat long enough to get through this chapter: it's going to help you.

**Torso Power—The Tuck.** I always begin my personalized training programs by explaining to the students that in time they will use the movements learned in exercise class throughout their day, therefore exercising constantly and continually.

The tuck tones stretch and strengthen the whole center of your body. It can be done unnoticeably—anywhere, anytime, in any position—and

therefore is the ultimate "sneaky." I[...] of every exercise you do so that eve[...] become part of your normal stance a[...] tion. If I have to choose one idea, one[...] that can transform any exercise into an[...] workout, and any body into a stronger,[...] and more injury-proof one, it is the sec[...] the tuck.

The tuck requires that you find the hollow in your center. Dancers use it constantly, almost unconsciously, to shift the weight from their lower bodies by using the torso muscles to lift the rib cage and support the entire body from the waist up. Gymnasts use it as the basis for their warmups. It is the basis of strength and alignment that allows these performers to do incredibly difficult movements with grace, beauty, and confidence.

Most exercise instructors hold the tuck when they exercise; however, they rarely convey the procedure to their students. In my program, however, the tuck is the focal point of every exercise. Whether standing, sitting, kneeling, or lying down, the exerciser is instructed to do the following:

ift the torso (ribcage)

2. pull the abdomen in and up under the rib cage
3. squeeze the buttocks in and under.

Through the tuck you will

1. develop firm and flat abdominal muscles
2. strengthen and protect lower back muscles, as well as enchance their flexibility
3. improve your posture
4. improve digestion and elimination
5. develop a girdle to protect internal organs
6. firm the buttocks
7. firm and tone thighs
8. tighten hips and ward off saddlebags
9. whittle your waistline.

The tuck exercises are based on your learning to create and maintain the concave hollow in the abdominal area while lengthening the front of the pelvis and opening the upper back. The idea is to constantly fight the gravity that keeps pulling down on our bodies. Sags and droops come naturally with the passage of time, unless you take the time and to fight them. The weapon is the tuck—it will keep (or make) you firm and lifted, as well as ward off aging and injury.

As you develop "torso power," you feel your strength, grace, and ability to perform grow. You feel power over your body and therefore over your life and its challenges.

The tuck is part of every sneaky exercise (in addition to every exercise I use in classes) and is at the root of all success. It is a *secret strength* that you develop and use all day long. It is the secret strength behind a spectacular body.

Maintaining the tuck demands and develops abdominal strength and a relaxed open back. These are the center of your fitness and well-being. It will take some time and persistence, but eventually the tuck posture will become habitual and you will find that you are constantly and naturally toning your tummy, protecting your back, and carrying your body with a newfound pride, grace, and elegance.

# Stretching and Relaxing

Stretching exercises are designed to make your muscles more flexible and to help you maintain a greater range of movement in the joints, tendons, ligaments, and muscles. The good news is that stretching is already a part of the movement you do naturally every day. Just as your dog or cat stretches after a good afternoon snooze in the sun, you should stretch when you wake up, too. It's an animal instinct, and the feeling is glorious. Stretching increases the flow of blood to areas that are being stretched, elongates the muscles, and reduces built-up muscle tension.

Stretching is the first step in a warmup. Combined with slow, easy running in place, or any other movement that brings that first glow of perspiration to your skin, it increases your body temperature and stimulates the release of fluids to the joints. A muscle supple with an abundance of blood is less likely to tear than one not warmed up.

To reduce the chance of injury when you stretch, do not bounce. Simply bend to the point at which you feel a mild tension in the muscles and hold that position until the tension lessens. If you cannot feel the tension easing up, pull back out of the stretch—you are probably pushing too hard too fast. Your muscles have a protective system that is activated when you overstretch. Nerve reflexes signal the muscle to contract, keeping the muscle from being injured, but the drawback is that this quick contraction can cause microscopic tears in the muscle fiber. Tears lead to the formation of scar tissue and a tiny loss of elasticity in the muscle, so if you feel no easing of muscle tension while holding a stretch, recognize this as your cue to pull back.

You can make just about any exercise more beneficial by employing proper breathing techniques. Remember always to breathe through your nose as if you are smelling a flower, and out through your mouth as if blowing out a candle. Exhale as you bend into a stretch, and breathe slowly and deeply as you hold the stretch. If you are lifting something or doing a static isometric contraction, blow out when you put the muscle to work and breathe in when you relax. The rhythm of the breathing should come very close to matching your body's demand for oxygen during the exercise. The more oxygen

you need, the faster and more deeply you should breathe. In extreme cases, moving against resistance while holding air in your lungs can raise blood pressure, causing lightheadedness, hypertension, vision problems, and, possibly, a heart attack.

## Isometrics and Isotonics

If you can move a muscle, you can strengthen many. Start putting an extra *umph* into the movement which is already a part of your life. Swing the baby high over your head the next time you lift her out of the crib—she'll love it as much as your muscles will. Pull yourself to your toes with each step up the front porch stairs. The more attention you focus on your muscles now, the more handsomely they will reward you in as little as a week.

Muscles work in groups and pairs, never alone. When one muscle contracts, its partner must extend. Muscles work to rotate, abduct, adduct, and circumduct joints. When you do put extra energy into a movement, you gain an extra ounce of strength. Physiologically, you are forcing your muscles to contract or extend a little more and a little longer than usual, calling oxygen-packed blood to the scene. Directly and indirectly, the added movement and subsequent rush of nutrients change the muscle fiber structurally by enlarging it. Protein synthesis, essential for building muscles, is speeded up. New tissue forms to allow muscles and bones to withstand the strain of exercise.

If the difference between isometrics and isotonics eludes you, here's your chance to sort it out. Isometrics are static exercises. Isotonic exercise, however, involves lifting the weight of either an object or a part of your body through space and against gravity. Isometric exercise allows the muscle to remain the same length while pitting one muscle against another or against an immovable object. Both pushing one hand against another and pushing against a wall are isometric exercises. Lifting your leg, swinging your arms, carrying your groceries to the car or your child up to bed are all isotonic exercises. When you succeed in lifting a heavy weight, you have exercised in an *isotonic* manner. When the weight you are trying to lift exceeds your strength, your exercise is isometric.

Isometrics have gotten some bad press along the way because squeezing your muscles temporarily inhibits the flow of blood to the contracted area. When you release, however, the fresh supply of blood which floods the working muscle brings with it extra oxygen and nutrients. Keep your contractions to eight seconds and breathe freely throughout, and you'll be getting the most from your isometric exercises. The light muscle training that isometrics provide can have a tremendous pain-preventative effect. If you're among the eighty percent of Americans who experience back pain due to inadequate muscle tone in the abdomen and lower back areas, isometric exercise is a good place to jump *off* the bandwagon. Also, postoperative or otherwise bedridden individuals are encouraged by doctors to use isometric exercises to increase the flow of blood through the legs and decrease the possibility of muscle atrophy and varicose veins. When you begin the exercises, you will notice that your everyday movements—even simply standing still— are often naturally isometric. "You can't stand without isometrics," says Dr. Fleiss. "Maintaining your posture for any length of time involves isometrics."

Strength may be measured by our ability to lift and move a heavy object. To increase our strength, we must progressively overload our muscles. As the body adapts to a certain amount of resistance, additional resistance must be placed on the muscle so that it is constantly being overloaded. In isometric exercises, the muscle is exercised against an immovable object and therefore the resistance is so great that no movement occurs. The muscle grows stronger because it is constantly being overloaded. In just one week of doing the isometric exercises in this book, you can achieve a ten percent increase in strength, and within four months, your strength will improve an average of forty percent, measurably and noticeably. For those just starting up an exercise program, there is no problem of endurance with isometrics—each contraction need last only a few seconds. There is no concern with space when doing isometrics because little movement takes place, and certainly no need for special equipment or finding time to fit them into your schedule. In mere seconds you can strengthen your muscles any time of day. Best of all, there is no membership fee for flexing your muscles!

If you're a woman who has not considered isometrics or isotonics because you are afraid of developing a man's bulk, relax. The male hormone testosterone makes men more prone to developing large lumps and bumps fast. In order to become extremely muscular, most women would have to work out with heavy weights strenuously for a long period of time. Although we are seeing more and more of this phenomenon as female weight lifters come onto the scene, be assured that such muscles don't happen by accident. Weight training on a less competitive, less rigorous level than that at which female weight lifters train will simply give you a well-toned shape.

It is impossible to develop muscle strength or endurance unless you have some muscle bulk with which to work. To add bulk where there is none, use heavier weights and perform fewer repetitions. Generally, if the weight you are using is heavy enough, twelve to twenty repetitions should have you breathing at a more rapid rate. Once you've developed the necessary bulk, move on to endurance training. You can increase muscle endurance by using lighter weights and doing forty to fifty repetitions. Having done that, you will then be ready to work on strengthening your muscles. Use the heaviest amount of weight that you can manage and do two to six repetitions. If you can go beyond six repetitions, you need to increase the weight that you are lifting. Remember that in shaping your body, you will achieve the most pleasing results with little chance of injury if you follow this step-by-step formula of developing muscle bulk, endurance, and strength. Anyone unfamiliar with weight training should seek professional instruction.

If you think you'll have to join a gym complete with mirrored walls and outrageously well-built men and women, fear not. There are objects around us at all times that can double as weights. This book can teach you how and when to use them. Be sneaky about it and no one will know what you're up to—until they notice that your waistline is shrinking. When carrying your briefcase, why not lift it up and down a dozen or so times? If you're walking down a city street, people will merely think that you are being politely accommodating as you squeeze in and around the crowd. Next time you're on the beach, take a look around for a sizable rock and

spend half an hour or so lifting it skyward. Your options are only as limited as your imagination, and once you start thinking fit, you'll have already won half the battle.

Important no matter what kind of weights you choose to lift, is the principle of overload, which is also used in isometrics. To benefit from isotonics, you must constantly be increasing either the number of repetitions, the amount of weight, or the speed with which you perform the exercise (overload). Start with an object that you can lift, at most, eight times. Once you can do this easily, increase the weight. Overloading should be done gradually so that the muscles are permitted to adapt without undue strain. Remember that although some muscle soreness is to be expected, you should never experience excessive exhaustion or discomfort. On certain days you might find that you are not reaching your usual level of performance; reasons for this can include inadequate sleep, lack of motivation, poor diet, or improper training. Listen to the message that your body is giving you, reduce the degree of overload for a few days, and get a good night's sleep or eat a healthy meal. Improvement

should follow, so don't be discouraged. This phenomenon, called retrogression, is common to all weight trainers.

If you don't stick with your isotonic exercises, the muscle tone that you've gained will disappear in much less time than it took you to develop it: the muscles' ability to use oxygen seems to disintegrate rapidly. Consequently, joggers and swimmers, who rely on their ability to take in oxygen for endurance, suffer more noticeably from a layoff than sprinters or weight lifters, who don't need as much oxygen. After a sufficient period of disuse, the muscle fibers grow smaller and weaker and become more apt to tear upon overexertion. It is not true, however, that muscle tissue turns to fat when not used. The reason your muscles become flabbier when you are out of shape is that portions of the muscle fibers fail to regenerate themselves and you lose the girdle effect that strong muscles have on fatty tissue. If you're trying to get back into the swing of things after a layoff from your regular exercise routine, you will probably find it easier to do so than would someone tackling the task of muscle building for the first time. In a sense, muscles

maintain a memory and are more apt to respond to exercise quickly if they were at one time exercised vigorously on a regular basis.

**What Is the Purpose?** The intensity and rhythm with which you perform the exercises in this book will determine their value for you. Always keep in mind the purpose of the exercise that you are doing. If you are lifting weights and want to increase your strength, make sure that you slowly build intensity by increasing the resistance or by changing the position or leverage. When you are exercising for suppleness or flexibility, make sure that your movements are performed to the fullest extent. Each bend or twist should be a completely controlled movement, punctuated by a beginning and an end. Each time you return to the starting position, let yourself go limp, relaxing your entire body before beginning again. Consciously relaxing between movements insures that you are fully tensing and releasing

*When you go dancing, dance! You can sneak muscle building and stretching into an otherwise aerobic exercise with this high kick.*

your muscles and thereby gaining the greatest benefit from the movement. Don't forget to incorporate the tuck into every exercise you do.

**Aerobic Exercise.** To stop huffing and puffing up stairs and prevent those legs from aching for apparently no reason, you need to start sneaking aerobic activity back into your life. While one could not have lived in the United States in the first half of the eighties and not be aware of aerobic exercise, too many of us know little more than that we ought to be doing it. Aerobic exercise strengthens the heart by causing it to beat faster and more forcefully. Your heart grows more powerful as you demand more of it, just as the muscles in your arms grow as you lift weights and your stomach tones up as you increase situps or tucks. Thus, the more you exercise, the more the heart pumps oxygen-rich blood to the body tissue, including the muscles, where it is combined with other fuel sources to produce energy. The blood then carries unwanted toxins like carbon monoxide (which can make your legs ache) back to the lungs to be released into the atmosphere. The more oxygen-rich blood is sup-

plied to the muscles, the faster the toxins may be removed. Consequently, the more fit you become and the better able you are to supply your body with the large amounts of oxygen it needs to function efficiently. When the increased supply of oxygen hits the blood vessels, they naturally lengthen, multiply, and branch out. Similarly, aerobic training can create drastic changes in the size, number, and type of muscle fiber. It also facilitates the use of blood glucose, which helps supply fuel to contracting muscles. Finally, aerobic exercise can enhance the elasticity of the lung tissue and increase the strength of the muscles in the chest.

As the lungs work harder to supply the extra oxygen and the heart beats faster to deliver it, you come closer to achieving an equilibrium between oxygen supply and demand. When, after months of working out, you strike that balance, you will have coordinated your body functions at a higher energy level and be able to exercise longer without feeling fatigued. If you find yourself gasping for breath after running for ten minutes, your cardiovascular system is not pumping blood efficiently. Your lungs are making a desperate attempt to pump more ox-

ygen-bearing blood to your body, thus the pounding heart and the shortness of breath. Long-distance runners rarely gasp for breath after a race because their cardiovascular systems are operating efficiently. Their bodies circulate large volumes of blood quickly, enabling their muscles to perform adequately. Studies have shown that in one minute, with forty-five to fifty beats, the heart of a well-conditioned person pumps the same amount of blood as the average person's heart pumps in seventy to seventy-five beats. Compared to the well-conditioned heart, the average heart pumps up to 36,000 more times per day, 13.1 million more times per year.

**Sex and Aerobics.** The psychosexual benefits of aerobic exercise have been under investigation recently, and researchers believe that twenty minutes of aerobic exercise raises testosterone levels significantly. This hormone helps the exercising muscles store energy in the form of glycogen. Thus, an increased energy level means an increased sex drive. Also, the more well-conditioned your heart, the more your body is able to handle the demand for blood in the genital area during sex, which trig-gers feelings of arousal. This and the self-confidence that comes from having a well-conditioned body helps you feel, and therefore act, sexier.

If you're feeling too fat to be sexy, you'll be glad to know that aerobics are also the best type of exercises for weight control. It helps your body to burn fat more efficiently by increasing the enzyme responsible for fat oxidation. As you increase your activity level, your body burns calories it would normally store as fat. As you lose fat, your body loses heat insulation and must spend more energy (calories) keeping you warm. Obviously, aerobic exercise increases muscle size. What is not so obvious is that for every pound of muscle mass added to the body as a result of exercise, from fifty to one hundred additional calories are burned. Lean muscle tissue burns calories more effectively than fat tissue—*even when at rest.*

The best time to exercise if you are trying to lose weight is within two hours of eating. When you eat, your metabolism speeds up to digest the food, giving you that all-over warm feeling that indicates calories are being burned. Exercise raises your metabolic rate further when it follows the meal and

for many hours after you've stopped working out. Exercise does not always increase your appetite. In the normally active person, exercise depresses appetite during and after exercise. More often, inactive people are the ones who feel the need to eat more calories than their body is able to burn.

**Sneaky Exercise During Pregnancy.** If you are pregnant and wondering whether sneaky exercises are for you, read on. As long as your pregnancy is normal and without complications, you can probably continue doing most of the activities you've been doing along with a few new sneakies. Pregnancy is in itself a kind of aerobic exercise because your heart beats faster, circulating about fifty percent more blood plasma. It might take as much effort to run one mile now as it did to run three miles previously. Although exertion diverts blood from the internal organs (including the uterus) to the muscles, if you don't exercise to the point of breathlessness, the fetus will continue to get enough oxygen and blood. Naturally, you should avoid any strenuous exercise in extreme heat or humidity and be sure to consume plenty of water. Sneaky exercises do not include the jarring movements that might be dangerous to the fetus toward the end of pregnancy when there is less room and cushioning inside the womb. You will be growing constantly, and consequently always altering your center of gravity. You may feel that you are working out with a new body every day. Although exercise can help you tolerate the stresses of pregnancy, labor, and delivery more readily, feeling fatigue or discomfort means it's time to stop. As always, listening to advice from your own body is best.

**Calories and the Four Principle Components.** It is important that you have a pretty good idea of how many calories your aerobic activity will burn. "Considering the four principle components of an exercise program—type, frequency, duration, and intensity—will determine how beneficial the program will be for you calorie- and otherwise," says Don C. Wukasch, M.D., heart surgeon and medical director of the Houstonian Preventive Medicine Center in Houston. The best type of exercise you can choose to increase muscular strength and cardiovascular endurance is aerobic, including brisk walk-

ing, jogging, swimming, cross-country skiing, downhill skiing, rope jumping, hiking, dancing, cycling, rowing (even on stationary machines), and bench stepping. To qualify as aerobic activity, an exercise must get you moving vigorously and steadily over a period of twelve to forty-five minutes, the amount of time it takes your body to shift from burning carbohydrates to burning fat. Unfortunately, some of your favorite sports like tennis, touch football, and golf make the cardiovascular system work hard in bursts, not continuously. Sports that include many starts and stops are more conducive to socializing than to strengthening your heart and body muscles. Also, while hard, intensive, infrequent workouts do suppress appetite at first, feelings of hunger shoot back up after the initial slowdown—for the next forty-eight hours! By building your strength, stamina, and flexibility through aerobics, however, your tennis game is bound to improve. Allow your ability to successfully compete in social sports to be one of the rewards you get from working hard to condition your body with aerobics. Beating your toughest opponent is sure to keep you motivated.

The best way to determine whether you are exercising intensely enough to reap aerobic benefits is to monitor your heartbeat. Ideally, you should aim for an exercise pace that raises the heart rate to seventy percent of your maximum heart rate. Calculate your maximum heart rate by subtracting your age from 220 and then multiplying that figure by .7. If you are thirty-two years old, for example, your maximum heart rate is 188 and your goal is 132. The first step in taking your pulse is to locate the carotid artery in the neck. It is the best artery to monitor because of its location and the strength of its pulsations. The carotid is at the front of the neck on both sides of the larynx. You should become familiar with the location so that you can quickly find it if necessary while you are exercising. Place all fingers, except the thumb, over the length of the artery so that you will increase your likelihood of identifying the pulse quickly and easily. When you feel the beat of the artery, count the number of beats in six seconds, then multiply this number by ten.

*Riding your bike back and forth to work lets you sneak by nerve-racking traffic jams and arrive at work revived and ready.*

For example, 7 beats in six seconds would be an equivalent of 70 beats per minute, 8 beats would be 80 beats per minute, and so on. Initially, it might be necessary to take your pulse periodically throughout the exercising period to make sure that you are progressing safely. However, once you become familiar with your routine, taking your pulse at the beginning and the end of your workout will be enough to see if you have exercised within your specific aerobic zone.

The older you become, the lower become both your maximal aerobic power and the maximal attainable heart rate. The senior citizen may be expending the same degree of effort exercising as a younger person, but his heart rate is considerably less. He is at the same percentage of his maximum capacity as the younger person. For example, if you are thirty years old, your maximum heart rate is 190 beats per minute and your proper exercise heart rate is seventy percent of 190 or 133 beats per minute. However, if you are sixty years old, your exercise heart rate should be kept down around 120. The aim is to stay in the target zone for your heart rate for fifteen to forty-five minutes. It is perfectly normal to be under

the target zone for five minutes or so when you are just beginning. Be patient with yourself—the rewards will be worth it. Remember that improvement of your cardiovascular capacity will enable you to do far more strenuous activities without feeling tired. Aerobics will make your heart stronger and more efficient, improve your circulation, build muscles, and lower blood pressure all at the same time. After a year of aerobic training, your resting heartbeat will decrease from 70 to 80 beats per minute to 55 to 65 beats per minute. Your resting heart will be beating thousands of times less each day.

In your earnestness to get your heart rate into its target zone, however, don't overdo it. Too many people drop out of exercise programs because they start doing too much too soon and end up sore all over. When the *intensity* with which you are exercising is inappropriate, you are bound to injure yourself. If your muscles ache after exercise, remember that it is only because, like any athlete who pushes beyond his limits, you have loaded your muscles with more toxins than they can handle. Waiting for soreness to go away is not the way out. If you stop exercising, you'll find it harder to start again and will more

than likely push too hard the next time—out of frustration and anger with yourself for failing the first time. Start slowly and work consistently, and there will be little or no soreness.

Although target zones and the duration of each session are crucial aspects of aerobics to consider, you can just as easily chart your progress by how you feel. Don't get too hooked on numbers. Learn to exercise aerobically until you feel you have done enough, and then push yourself just a little more before you stop. If you do this with each session, you will improve little by little. There will be days when you don't feel like doing much, and you should not reprimand yourself. Compare today's effort with last month's effort and pat yourself on the back. The goal is to improve little by little, day by day, year by year.

Frequency of exercise is just as important as type, duration, and intensity. "Exercising three times a week is frequent enough to maintain your fitness level, but it takes four times a week to improve it," says Dr. Wukasch. Unfortunately, the media have overplayed the three-times-a-week-for-twenty-minutes formula, and too many of us have been discouraged when that didn't seem to be enough. You can sneak in an extra session each week simply by exercising every other day.

Remember that you don't need to be an athlete to exercise. Many of us who found sports difficult during our school days have turned into dedicated exercisers—including me. Until recently, our society has generally associated aging with inactivity. There is no need to accept the passing of years passively. I have found that after fifteen years of exercise, I am more slender and firm than when I started. Interestingly, exercise can also help you solve problems more easily and help you be more creative. Exercise scientists have found that rhythmic, repetitive action transfers the focus of the brain's energy from the left hemisphere, where rational linear thinking is centered, to the right hemisphere, where intuitive thinking is centered. We become more alert, attentive, energetic, and self-confident.

**Walking Is Aerobic, Too.** Convinced enough to take your first few steps of exercise? Keeping intensity, duration, and frequency in mind, begin to sneak walking back into your life. This time should be even

more cause for celebration than the first walking steps you took as a baby! Walking is rhythmic, natural, almost effortless movement. Stand up straight with your chest lifted, your head up, your back straight, your feet pointed straight ahead. Land on your whole foot, rocking from the heel to the ball of the foot. Don't walk on your toes or turn your feet in or out. Don't think about your breathing; the rate of your breathing will increase naturally. *Never* exercise to the point of breathlessness. Move your arms vigorously when you walk, and you will give your shoulders, triceps, and forearms a workout too.

No excuses—don't hold up bad knees, feet, or hips hoping to get out of this. Walking *strengthens* the bone composition. The healthful physiological stress that it places on the skeleton increases bone density and keeps bones from losing minerals. Almost unbelievably, the benefits of walking equal the benefits of more strenuous aerobic activities like running. (A good jogging shoe with a wide, high toe

**W**alking—experts are saying it's the best exercise in the world. Do it anywhere in the world.

box, and a thick supportive sole and heel is best for this.) Muscles are flexed 1,500 to 3,000 times during every mile walked—more than almost any other exercise. Aggressive walking is the perfect excuse for the overweight to burn 300 calories per hour and lose inches from their hip measurement. It is also recommended for those with conditions such as arthritis in that it lessens the symptoms of the disease and improves muscular flexibility. People with emphysema have been helped by walking, and it is a well-known fact that people who are recuperating from heart problems have found walking to be the perfect exercise. It stimulates the flow of blood without putting any undue strain on the heart, although you should check with your doctor if you have a history of coronary problems. Walking is the exercise of choice, because with minimum risk one can maximize aerobic benefits.

Sneak in your first walk. Some people find that they prefer to fit their walking into their lunch hour. Instead of sitting around the office and cramming down a sandwich, choose a restaurant that's about a thirty-minute walk away from your office. Or walk briskly for thirty to forty-five minutes as you window shop. You are bound to find that you are less hungry and eat less weighty lunches. Try walking at various times and in different places to find what works best for you. If you are the type of person who needs variety in your life, there are many ways to alter your walking program that will keep you interested and active.

To begin, try choosing a store one mile from home and walk there briskly. Alter the duration or intensity of your walk by changing the destination or your pace. Many of you will find that sneaking a walk into your life in the evening, either before or after dinner, is ideal. After a long, hard day's work, a good walk can be just the thing to help you settle down and tune up. It can be stimulating or relaxing. You can choose to think or not to think. Taking a brisk walk with a friend around the neighborhood can be much more relaxing than sitting through happy hour at a bar.

Commuting may be the perfect way for you to get your aerobic exercise into your schedule by walking to work, or walking home at night, or both. Once you get into the routine, you might find that your walking days are so much more produc-

tive than your other days that you will do it every workday. If you live far from work, take public transportation or drive partway to work and walk the rest of the way.

The best walking pace is about four miles per hour, which amounts to a fifteen-minute mile. If you walk three miles at this pace, you should have forty-five minutes as your target zone. Choose a one-mile stretch by clocking it off on your car's odometer. Now time yourself as you walk this one mile at a brisk yet comfortable pace. You will probably find that it will initially take more than fifteen minutes to walk this mile. Don't give up! Before long you will find that you can cover the mile in fifteen minutes, and with a little more time and effort you will be able to do a round trip in thirty minutes. Soon, you will be walking four miles in one hour.

Your pulse should reach the target zone soon after you start walking, and you should have little trouble keeping it there for most of your walk. If your heartbeat slips below target zone, increase your intensity. You might do this by picking up speed. If you haven't been active for a long time, it may take four to six weeks of walking regularly to reach your target zone quickly.

It is best to walk on a flat surface that has a bit of give, such as dirt or grass. Although there is little danger of injury when walking, when at the beach, consider the fact that the best sand is damp but not deeply wet, where the tide has just gone out. It is best to embark on a program where you begin on firm sand and progress slowly to soft. Be careful when walking down steep slopes, as they tend to make your knees act like brakes, and can also strain your back.

You should be able to carry on a normal conversation while you are walking and not become breathless. You shouldn't feel pain as you walk. If you do, consult a physician. You shouldn't be extremely tired after your walk, but you should feel that you have made use of your body. If the walk is too strenuous and you feel exhausted, slow down and cut back. Make sure that you are aware of the clues that your body is giving you so that you can handle them correctly. You are the best judge of what you can handle. Tune in to your body's needs, be aware of its vulnerabilities, and prepare to enjoy the benefits of improved physical conditioning. Quite simply, becoming a pedestrian puts you on the right road to a longer and fuller life.

# LESSENING STRESS

The "super" phenomenon has struck. Super-moms, super-pops, super-kids, super-bosses, super-workers abound. Just as the plague of the fourteenth century was bubonic, stress has become the twentieth-century plague. Some of us play as many different roles as there are hours in a day. When the energy that we wake up with in the morning runs out, we simply switch to overdrive and run on stress. "There's an exhilaration that comes from being on the roll, in the middle of an exciting, fast-moving lifestyle," says Dr. Wukasch. "Unfortunately, having your motor racing twenty-four hours a day is going to burn it up mighty fast."

Stress stimulates a basic biological reaction called "fight-or-flight" that originally evolved as a reaction to danger. Primitive man did not worry about the IRS, the decline of the stock market, or the increased crime rate while sitting quietly at home in his cave. A bear coming down the mountain, however, set off a built-in alarm system. Stress generates cordical alarm signals that activate the hypothal-

*C*ool off a temper by pushing against the refrigerator. It won't go anywhere, but your temper is bound to go away.

amus, which in turn activates the sympathetic branch of the autonomic nervous system that governs involuntary, spontaneous action. This activation causes a wide variety of physiological reactions.

1. Heart rate and blood pressure increase to pump the blood with greater speed and to carry oxygen and nutrients to the cells, thereby clearing away waste products more quickly.

2. Rapid breathing increases oxygen supply.

3. Dilation of the pupils lets more light in.

4. All senses are heightened.

5. Muscles, especially the major muscles, become tense.

6. Flow of the blood to the brain and major muscles increases as a result of an adjustment in the adrenal system.

7. Blood flow to the digestive organs decreases so that more can go to the muscles.

8. Blood flow to the hands and feet is reduced so that there will be less bleeding in case of injury.

9. Stored sugar is released by the liver into the blood so that increased amounts of fuel to the muscles are available.

10. The body perspires to relieve itself of the increased heat generated by all the extra activity.

11. Hormones are released into the blood to improve blood clotting capacity in the event of injury.

No doubt, after winning a fight with a bear, primitive man walked away from the scene with minimal muscular tension. Unfortunately, in the thousands of years that have passed, the physiological preparations for violent exertion still occur under stress, but the society we've created doesn't allow us the release of a good fight. Of course we've all daydreamed about expressing our anger at the IRS with vigorous muscular activity, but in reality we're stuck with muscles tightening in the jaw, neck, shoulder, lower back, and hands. Not surprisingly,

it is estimated that 90 percent of all headaches are caused by muscle tension either in the jaw or in the neck and shoulder area, according to Avi Raphaeli, Ph.D., a psychologist in Houston.

Most of our physiological responses to stress are controlled by the hypothalamus, a small portion of the brain that controls emotions, appetite, and thirst, and helps to regulate hormones. Under stress, the hypothalamus signals the body to release a variety of chemicals, including adrenaline. Adrenaline causes the heart to beat faster and sugar levels to soar, creating a state of physiological arousal similar to the stimulating effect of caffeine, nicotine, and alcohol. Just as we can become addicted to those drugs, we can get hooked on hormones that are released when all other energy reserves are sapped. This is why so many of us leave assignments until the last minute, or rush to the airport just as the plane is preparing for liftoff. Even watching someone else experience stress in horror movies keeps us on the edge of our seats.

It is crucial that we learn how to draw the line between energizing stress and the kind that takes its toll on our looks, our bodies, and our emotions.

The negative reactions to stress can be felt in our aching backs, our tightened throats, palpitating hearts, elevated blood pressure, churning stomachs. We come to feel depressed, short-tempered, and may suffer from insomnia or impotence. Ultimately, stress in the form of infections, ulcers, heart disease, asthma, and cancer can be fatal.

The way that we perceive everyday events determines their stress potential, so a problem arises when the stress fight-or-flight reaction is too easily and inappropriately evoked. Positive and negative situations can cause identical stress. One might experience the same stress when getting married as he would when getting divorced. Positive or negative, however, we can handle just so much stress before experiencing physical or mental damage or dysfunction. Apparently, some people can handle more stress than others. How well you recognize stressful situations determines how well you are able to control and to avoid anxiety-related illness.

By modifying your perceptions, you can reduce your stress. Waiting on long lines, a situation many of us find stressful, is a good place to start modifying the way you perceive your surroundings. For exam-

ple, if you find yourself waiting on line to see the latest film, rather than worrying about the time being wasted, focus on the fact that the movie must be quite good to merit such a crowd. A line at the grocery store check-out counter can be turned into time spent reading the latest magazines stocked by the register. We each have a certain amount of energy to spend and it's a tremendous waste to spend any on insignificant problems. When you feel the symptoms of stress creeping up on you, stop and decide whether the issue at hand is really worth all the tension you're allowing it to create. Does it really make a difference? Is there anything you can do about it? Will clammy hands, a racing heart, a tapping toe really change the situation? Learn to blow the whistle on your body and regain control.

It has been found that stressful events such as pregnancy, loss of job, divorce, and death of a loved one can be handled because we prepare for them. Traffic jams, overwork, family hassles, or any unexpected changes in our daily routine are the most debilitating. To handle such situations, play the

*B ig event nerves? Find a wall and push.*

"what if?" game with yourself and imagine how, for instance, you might best cope with a traffic jam on the morning of an extremely important meeting at the office.

The downfall of too many super-people these days is the inability to decide which comes first: career, children, spouse, or personal needs. Hard as it is, you must choose. Fortunately, you may alter your list of priorities every day if you wish. The kids get you today, the company gets you tomorrow, and you and your husband get the weekend together. Easier said than done, yes—but living without priorities can be even harder. Have a plan of action and stick to it.

If all that just struck a chord, you're no doubt a super-person afflicted with what's medically and popularly known as the Type A personality. Do you often fall prey to an excessive competitive drive, impatience, aggressiveness, a compelling sense of time urgency? Do you try to compensate for what you feel are your deficiencies by overachieving? Do you become furious when you are forced to wait in line and intolerant with people who speak or act slowly?

Perhaps it's time to incorporate smiling, daydreaming, and enjoyment of simple pleasures into your life because you're doing the tango with the major killer of middle-aged people in the United States—coronary heart disease. Like a string instrument, you need enough tension to make music, but not enough to snap.

Stress is connected with everything that would predispose one to heart disease. Smoking is related to heart disease; many people who cannot stop smoking say that it is due to stress. Obesity is also connected with heart disease; people who overeat often do so when they are severely stressed. There are even some indications that stress is associated with the buildup of cholesterol in the blood stream. If the coronary circulation is diminished owing to the narrowing of coronary arteries, a sudden stress-induced increase in pulse rate may be enough to cause chest pain or even a heart attack. Moreover, the constant flow of adrenaline and other chemicals that are released under stress can cause much damage to the heart muscle. High blood pressure is also related to stress, and doctors have found that hypertension can be greatly re-

duced through programs that emphasize stress management, exercise, and weight loss.

Infertility is a twofold problem for women because stress decreases the sex drive and interrupts the menstrual cycle. The hypothalamus and the pituitary glands have trouble working together to release the hormones that regulate ovulation. No period, no pregnancy. Male fertility is also affected by stress as the cooperation of the hypothalamus and the pituitary are relied upon to stimulate continuous testosterone and sperm production. The hormone disruption may cause a decrease in sexual desire in both men and women. Ironically, sex, when it is a mutually caring experience that allows us to ignore daily pressures, can provide a tremendous physical and emotional release of stress.

Our backs may be the part of our body most vulnerable to stress. Since our bodies were not originally designed to walk erect, our lower backs are a place where a great deal of tension settles. Only twenty percent of back pain has a specific pathology as its origin; that means eighty percent is caused by weak muscles and stress. Although we tend to be very insulted when we're told that our pain is psy-chological, correlation between stress and back pain is undeniable. Remember that when an illness is psychological, its pain is no less real—it's simply the cause, an emotional one, that is self-induced.

Stress is likely to affect both how you eat and how you digest what you eat. Diarrhea or general intestinal disorders may result because hormones released under stress cause the blood to rush to the heart and other muscles, leaving less blood to help the digestive system with large quantities of food. Eating often and in small quantities, and not letting your stomach ever get to the growling stage, are advisable when under stress. This, on the other hand, may prove difficult because we tend to lose our appetite when stressed. The adrenaline that surges into our bodies during stressful situations allows fats and sugars to be released, which in turn raise blood sugar levels and squelch hunger.

The reason people often binge under stress even when they are not hungry is because as children some of us are taught to use food to calm ourselves. When baby cries, we pop a bottle in his mouth. When baby is good, we give him a cookie. To unlearn the habit of eating as a release from stress

or as a reward, you must recognize the reaction as such and sneak it out of your life. Remember, it is not how much stress you are under that causes the disorder—be it an ulcer or other problem—but how you handle the stress.

## Choosing a Stress-Relief Program

Since each of us reacts to stress in a uniquely personal way, it is imperative that we be selective when choosing a behavioral technique to help ourselves. All stress-reduction techniques slow down heart rate, blood pressure, breathing rate, and oxygen intake, and lower the metabolic process substantially, the opposite of what happens to us during the fight-or-flight response process. Learn to be sensitive to the clues that your body gives when you are pushing too hard and discover where your body collects tension. You'll most likely find it gathering in one of the common tension "centers": shoulders (tension produced here often spreads to the neck, causing headaches and other discomfort); jaw (clenching your jaw and grinding your teeth, unknowingly done in your sleep as well as in the daytime, can cause severe headaches); forehead and scalp (tension in these areas can cause behind-the-eye headaches); buttocks and anus (disorders of the colon can result from chronic tension here); stomach and abdomen (ulcers); neck (headaches, fatigue, and stiffness). Identifying where muscle tension crops up under stress can help you reduce the problem quickly through a suitable relaxation technique.

Keep in mind that none of the programs that follow will relax you instantaneously. If you have been living under stress for months or years, you may be so accustomed to feeling tense that the notion of relaxing seems foreign. In reality, *most* of us seldom experience the feeling of total relaxation. Methods like meditation, yoga, self-hypnosis, and biofeedback are shrugged off by many as quackery. Unfortunately, it is usually those who are most in need of this type of training who are most likely to fight it. Just this once, I hope you will give one or all of the following techniques a try. Think of relaxation as a skill to be learned and to be called upon whenever stress starts mounting. It will allow you to

reestablish a feeling of control and to stop the stress that accumulates during business hours from snowballing into your personal life—and vice versa. How can you resist?

**Transcendental Meditation.** In learning how to sneak this type of relaxation response into your daily life, the first thing is to find a relatively quiet environment. I know this might be difficult, especially for city dwellers, but if you look you can find a place that is relatively peaceful. It is important that you sit in a comfortable position with your back supported and your feet flat on the floor so that circulation is unimpeded. Your hands and arms should be in a comfortable, relaxed position, preferably not touching the rest of your body. During the meditation, your head may fall forward onto your chest. It is best to be sitting in a balanced position so that your neck muscles can be relaxed. The word or sound that you either say or think to yourself is called a "mantra." Any word that sounds soothing, without hard consonants, works well. The word should not mean anything to you: for instance, the sound "ah-room" works well because it calls up few mental images. Other mantras are words such as "om" or "aom." You might choose to stare at an object in the room or focus on a spot on the wall to avoid and discourage distractions. However, most people find it works best to close their eyes and mentally picture a design, an image, or simply nothing at all. The goal is to clear your mind of the day's discussions, problems, and events. By continuously repeating the mantra you have chosen, you will lull your mind into a state that will be resting and soothing. Learn to replace all the voices in your head with the mantra. It's like unplugging all the lights but leaving one bulb burning in a completely darkened room. You will come to feel that there is nothing to worry about, that there are no demands to be met, that everything is calm and in control. *Let go for fifteen minutes.* Repeating the mantra will make it difficult to think about anything else. However, it is important that you do not try to relax, but instead *allow* yourself to relax. Upon completion, breathe deeply, stretch, and return to reality refreshed. Ideally this should be done twice a day for fifteen minutes, whenever and wherever you please. Try doing it on the bus to work, for example, where the

humming of the motor will drown out other background noises that might be more distracting. What is important is that you learn *how* to clear your mind when necessary. If it seems like a tremendous waste of time to merely sit still for fifteen minutes listening to yourself breathe, perhaps you should try thinking of it as a time to recharge your batteries. It is a passive activity that prepares you for action.

**Self-Hypnosis.** Do you know the feeling that you have just before falling asleep at night when your mind starts to wander, but you are still aware of your thoughts? That's the same feeling you experience in hypnosis. Your conscious self can talk to your subconscious self and give it suggestions. Your subconscious keeps tabs on the past and has a lot to do with who you are in the present. For example, if as a two-year-old you learned from Mommy that she would give you a cookie if you were good, the two year old in you, no doubt, still looks for something sweet as a reward for an accomplishment. Through self-hypnosis you can have your adult conscious self talk to the child in you and straighten out your poor eating habits. Once you have

learned to use this valuable tool, you'll turn to it again and again to help you do or undo troublesome tasks throughout the day. If you allow it to, self-hypnosis can help you stop smoking, stop overeating, accomplish athletic feats, or go through your usually stressful day with a less tense attitude.

Ready? To begin, get yourself into a comfortable position. Take a few deep breaths in through your nose and out through your mouth. Close your eyes and say to yourself, "I feel completely relaxed." Repeat this phrase to yourself five times very slowly. Now, imagine your head feels very heavy and your neck tension free. Repeat slowly to yourself: "My head and neck feel totally relaxed and tension free." Imagine that your head is made of lead and that you can barely lift it. It might take some practice for you to actually feel what you're trying to imagine, but be patient and believe in the power of your mind over your body. Now, to enter a hypnotic state, use the formula HEAL: head, eyes, arms, and legs. Close your eyes and think about being totally relaxed. Begin by relaxing your head, then your eyes, your arms, and finally your legs. Allow all the tension and pressure to pass down through

your body and out of your toes. When you say "head," feel your head relaxing and letting go of tension. You should be getting a feeling of warmth and weight in each area of the body that you focus on. Finally, repeat the phrase "I am deeply relaxed and at peace" several times. You will then be able to discuss with your subconscious any matter on which you wish to work. This can be done anywhere, any time that you are able to close your eyes. With practice, you will relax as quickly as you can say "head, eyes, arms, legs" to yourself. This method is excellent for helping you to relax and fall asleep at night when done in bed. You can use it to help you get through stressful situations, such as giving a speech to a large group. Merely relax and tell yourself that you will not be nervous and that you will do a wonderful job. If you want to relieve tension from a specific part of your body, close your eyes, go through HEAL, and then focus on relaxing the trouble spot. Upon completion, breathe deeply, stretch, and enjoy your newfound inner peace.

**Catching Your Breath.** In your most frightening and threatening moments, the fight-or-flight response takes over and you have no doubt responded with breathing that was shallow, rapid, and irregular. When we are tense, we breathe only with our upper chest. Many of us go through much of our lives breathing this way. However, when we are asleep, we (like babies) breathe deeply from our diaphragm. Shallow breathing supports tension; deep breathing breaks it down. Learning to breathe deeply, regularly, and automatically can assist in reducing or eliminating constricted muscles and induce a refreshing sense of calm and relaxation. Proper breathing is the foundation of practically any relaxation method. When you focus on breathing, you take attention away from your problems. Breathing deeply and slowly increases the negative pressure in the chest, which helps draw blood toward the heart through the lungs via the large veins. An increased supply of blood to the heart helps maintain the pressure of the blood to the brain and away from the muscles that are seeking more blood in preparation for the fight. As you are breathing deeply, you might want to think of a calming word. For example, breathe deeply and, as you exhale, spell out "s-l-o-w-l-y," to remind yourself to let the

air out slowly. You might want to close your eyes, listen to your breathing, and try and memorize the sense of relaxation stealing over you so that you can recall it next time you feel stressed.

**Tighten and Lengthen.** Tighten every muscle in your body as much as you can. Close your eyes tightly, clench your fists, and curl your toes. Hold the contraction for no longer than five seconds as you continue to breathe deeply. Let go and relax. Repeat the muscle contraction, but this time instead of tightening every muscle, think of lengthening every muscle. Open your mouth wide as in a yawn, raise your eyebrows, stretch your arms, legs, fingers, toes, and neck. Again, hold the stretch for five seconds while breathing continuously. Release the stretch and let your whole body feel loose, limp, heavy, and relaxed.

**Gradual Relaxation.** In gradual relaxation, instead of going from full tension to full relaxation, stop at the levels in between. You might want to do one part of the body at a time. For example, tense your arm slightly at first, then a little more until,

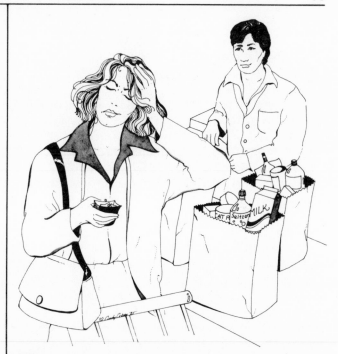

*When inflation knocks you over the head, fight a bad case of consumer crabbiness with this sneaky exercise: push head against hand, hand against head.*

after ten seconds, the arm has reached maximum rigidity. Your return to relaxation takes place in stages also. Decrease from tense to less tense to even less tense, to the original limp state. The idea is to let go in gradual steps, so that you will be able to recognize tension even in its minimal stages. This way you will be able to monitor the various muscle groups and grow familiar with the areas that are most vulnerable. At various times throughout the day, check in on your body's tension centers and use the gradual relaxation method to press out the kinks.

**Shaking Tension.** Another way of systematically relieving tension is to shake it out. When you discover tension in a certain section of your body, let it first go limp and then shake it. For example, if you feel tension in your arm, shake it loosely allowing your entire hand, shoulder, and arm to vibrate. You might want to use a systematic detensing shaking method by starting first at the top of your body, shimmying your shoulders, shaking out your arms, hands, legs, and feet. Afterwards, your body should feel a relaxed tingling sensation.

**Massage.** To touch is one of the most basic forms of communication, and through self-massage you can tell yourself to slow down, unwind, relax, and feel better. Finding tight muscles in need of relief with your own bare hands will help you further tune into tension centers you might not otherwise have been able to pinpoint.

To relieve soreness in your lower back, make fists and bring both hands behind your back. Place them as high on your back as you can. Briskly rub the muscles on either side of the spine with the knuckles of your fist. Move all the way down to the lower buttocks and then massage up again as far as you can reach. Do this for about thirty seconds and your back will feel less tense and you will feel less fatigued.

To relieve tension in your shoulders and upper back, reach across the chest with your hand and grasp the big muscle at the top of the opposite shoulder. With your fingertips, find the tightest part of the shoulder and firmly grasp the area for about thirty seconds until, as you rub deep into the muscle beneath, you feel the heat of your fingers. As soon as you do feel the release, you will find that the ten-

sion and pain in your shoulder will be reduced. Do the same on the opposite shoulder.

To relieve tension in your neck and head, use your fingertips to gently rub tiny circles into your temples. You also want to use your fingertips to rub across the lines of your forehead, releasing the tension in this area. The same might be true for the area of your neck behind and beneath your ears.

**Visualization.** When faced with seemingly insurmountable pressures at the office, walk over to the nearest window; where you may see a dingy city street, visualize a country path. Close your eyes and picture yourself in a leafy glen, floating on a lake, lying in a hammock, resting on a cloud—place yourself in a situation which will give you the feeling of total, utter relaxation. Don't be embarrassed to use your imagination. No one has to know what you're doing and it makes a terrific stress release. The power of visualization is such that cancer patients have seen their illness go into remission by visualizing,

*T*his sneaky exercise works hands-down every time. Press down on a desk or similar surface and feel tension take a time-out.

thereby helping their bodies to produce an excess of white blood cells which destroy disease. Visualization may also be a good adjunct to any one of the relaxation methods described so far. For example, when using self-hypnosis, begin by picturing yourself curled up in your favorite chair in front of a warm fire. It will be a mental warm-up for relaxing your body parts.

**Three-Two-One Let Go.** This method is designed to help you produce mental and muscular relaxation within a few seconds. It might take a little practice, but in time you will find that it will work wonders for you and can be used throughout the day spontaneously. Begin by closing your eyes and relaxing in a comfortable position. In your mind's eye, see the number three as you inhale. As you exhale, repeat to yourself, "I am feeling more and more relaxed." Watch the number three melt into the number two as you again breathe deeply and repeat, "I am becoming more and more relaxed." As the number two melts into the number one, let go of all tensions completely. Sit quietly and take a few seconds to enjoy the relaxation you've achieved.

Stretch a little, open your eyes, and continue with the day's activities. If your day consists of many high-pressured phone calls, take a few seconds every time you hang up the phone to go through this method. You will be astounded at how it will help relax you and keep creativity flourishing.

**Wondrous Water.** Nothing feels better for relief of tension in the neck and shoulders than letting the strong spray from the shower massage the area. Allow it at least twenty minutes to work its magic. Use the time to clear your mind and think only pleasant thoughts. If you prefer to bathe sitting in the tub rather than standing in the shower, try enhancing the experience with bubbles or bath salts. Dip a towel in hot water and wrap it around your neck. You will feel sore, aching muscles melt away and tension go down the drain. Put on soft music, take a glass of wine or club soda with you, and enjoy the experience.

**Laughter.** A good hearty laugh can rev up your cardiovascular, respiratory, and nervous systems, it can be emotionally stimulating, and it can induce

muscle vibrations that are often followed by a feeling of enhanced relaxation. Many hospitals believe in laughter to the point that "humor programs" have been set up in brightly colored rooms in which patients and their families can watch lighthearted films, play games, and enjoy a good time.

**Exercise.** Exercise is a form of active relaxation which has enormous stress-reducing ability. When exercising, it is difficult to focus on the anxiety-producing events of the day. It is tough to be flustered by your secretary, concerned about your accounts, or worried about your child's grades when you are busy making muscles. People who exercise are truly less irritable, experience fewer mood swings, and are generally less depressed than those who are sedentary. Stretching, an excellent way to tone muscles and increase flexibility, is one of the easiest, most natural forms of exercise to sneak back into your life and a terrific way to relieve stress. Quite simply, since muscles contract when we're tense, stretching them out gets stress out. Just be sure not to overdo it.

Overexercising can prove more stressful than

*L*eg stretches like this one not only tone back-of-the-leg muscles, they also give blood a boost on its climb back up to your heart. The tension you release will help you through the toughest conversations.

beneficial. To be relaxing, exercise must be seen as something you want to do, something you like to do, and not something you are doing for constant results or to compete with yourself and others. It is not necessary to constantly "go for the burn." That only adds an additional anxiety-producing situation to your life. Most people do not begin to really feel the relaxation of exercise until they are able to participate comfortably. The problem for many exercisers is that they never allow themselves to stick with a program long enough to start feeling both the psychological as well as the physical benefits. This might be because they don't begin with programs that are suited to them, or don't see results quickly enough to keep them going. That's why the sneaky exercises you're about to come across in the next chapter are going to work for you. They will become an integral part of your day—naturally. So relax.

# SNEAKY EXERCISE

## The Right Frame of Mind

The many exercises that follow have been categorized according to the area of the body that they benefit. The illustrations show sneaky exercises being performed at specific locations, although none of them are dependent on surroundings. The illustrations should merely trigger your imagination.

Do more than simply read what follows. These exercises can help you get to know your body better; therefore, listen to its warning cues and to its thank yous. These exercises will make you less afraid to look at your body honestly and openly in the mirror and will teach you to like what you see.

Be sure to do the same number of repetitions on each side of the body for those exercises that can be done so. Also, increase the repetitions of each exercise as your strength and suppleness increase.

Don't be alarmed by the number of exercises that follow. There are so many so that you have a choice. You don't ever have to do them all, and

**M**ake the most of your ski pole with this side stretch before a long run down the slopes.

certainly not all at the same time! Start small with something you can do while reading the newspaper or riding to work on the bus. For instance, right now, while you're reading this, spread your fingers apart as much as possible. Now curl them into a tight fist. Now relax. Do it several times. Now don't your fingers feel a little more supple, perhaps even a little warmer? Now imagine the feeling in your hands flooding your entire body, and you'll have an inkling of what the following sneaky exercises are going to do for you. Enjoy them.

**Key to the Exercise Categories\*** Remember that the tuck should be a part of every exercise, so that each has the additional benefit of toning the torso and the abdominal muscles while loosening the lower back muscles.

- Stretching and Relaxing

★ Isotonic and Isometric (toning and strengthening)

■ Aerobic

\*A combination of these symbols means that the exercise is beneficial in more ways than one.

## The Neck

Posture plays a great role in avoiding neck and shoulder strain. When you are standing correctly, the back of your neck will have a forward curve and your head should be properly aligned, balanced directly on top of your spine rather than tilting backward or forward. It is no wonder that the neck is such a vulnerable part of the spinal column, when you consider that just seven small vertebrae must support the heaviest single part of your body—the head. Projecting the head and neck forward, which results in the most common neck ailments, forces shoulders into an unnaturally raised position. If you're constantly tilting your head to one side, you may tend to get a stiff neck often, one-sided back spasms, or pinched nerves in the neck. If you are more apt to hold your head back, and your chin up, you are putting undue stress on the muscles in the back of the neck and skull. Do you recall the feeling you had in your neck the last time you sat too close to the screen at the movies? Keep in mind that although the neck bones and disks are the smallest in the spinal column, they also have the greatest

range of movement. Thus, your neck may react violently to an injury so minor that you can't even remember doing it.

Pain and stiffness in the neck can also be caused by emotional and nervous tension, occupational strain, or short, weak muscles in the neck area with little elasticity. Arthritis, characterized by bone spurs in the joints, may also afflict the neck. Although inactivity is often the reason for neck pain, if you are exercising with your body out of alignment, you are also, no doubt, prone to a stiff neck every now and then. You may find yourself tensing the muscles in your neck as you try to brace yourself for physical activity that has nothing to do with the neck. Commonly, people just beginning to exercise have trouble isolating muscle groups, and are apt to become overly tense in various places throughout their bodies, including the neck.

## Exercises for the Neck

• Let your head drop freely. Feel your neck relax into this position. Lift your head back to the starting position.

• Look straight ahead and make a circle with your face—pretend you are drawing a circle with your nose. First go around in one direction, then in the other.

• Massage your neck with your hands, kneading the skin until you feel an increased sensation of warmth in the area.

• ★ Drop your chin to your chest, and clasp your hands at the base of your skull. Pull down very gently, letting the weight of your hands stretch out the back of your neck. Use your hands as a resistance when you try to return your head to an upright position.

• ★ Pull your head as far back as possible, keeping the chin level, then bring your head as far forward as it will go. Repeat.

• Keep your shoulders relaxed and do not let your head tilt. Look over one shoulder as far as you possibly can, then over the other.

• Touch your chin to one shoulder and then nod "yes" all the way across your chest until you reach

the other shoulder. Repeat to the other side.

• Drop your right ear to your right shoulder, then your left ear to your left shoulder in a slow, continuous arc back and forth, passing through a position of proper alignment and balance at the center of each trip back and forth.

★ Hold your fist firmly under your chin. Press your chin down against your fist. At the same time, push your fist up against your chin. Exhale as you hold for six seconds. Relax. Repeat.

• Let your head fall over to your right shoulder as if you were dozing off. Bring it back to center and then nod off in the other direction.

• Rest your right ear on your right shoulder. Keeping your head in this position, let your head roll forward toward your chest. Lift your chin away from your chest. Bring it back down to your chest and continue to roll until your left ear is on your left shoulder.

★ Put your hand against the right side of your face from temple to jaw. Try to rotate your head to the right as you resist with your hand. Exhale as you hold for six seconds. Relax. Repeat. Do the same on the left side.

★ Clasp your hands behind your head. Press back as hard with your head as you resist with your hands. Exhale as you hold for six seconds. Relax. Repeat.

• ★ Stand or sit with your back close to a wall. Press your head back against the wall as hard as you can. Relax. Repeat.

★ Stand or sit with the side of your head against the wall. Press your head firmly against the wall for six seconds. Relax. Repeat. Now do the other side.

★ Stand or sit erect and clasp your hands behind your head at the base of the skull. Your elbows should be up, forming triangles with your body. Now exert pressure with your head, pressing back against your hands. Relax. Repeat.

★ Repeat the previous exercise, but this time have your clasped hands against your forehead so that you are pushing forward with your head against the resistance of your hands.

*A* void jet-lag sag with this sneaky de-tenser and toner to do when traveling. Put a hand against your head and push one against the other.

- Rest your right ear on your right shoulder, keeping your head as close to your shoulder as possible, and roll your head backward toward the center of your back so that you are looking straight up at the ceiling. Continue to roll until you are resting your head on your left shoulder. Repeat.

- Stand or sit and bend forward from the hips so that your head is below knee level. Relax the muscles of your neck and gently shake your head.

- Tilt your head directly back as far as you can over the center of your body and look up at the ceiling. Keeping your head back, turn your chin toward your right shoulder, let it go back to the center, then turn it toward your left shoulder, and let it go back to the center.

## The Shoulders and Upper Back

Do you feel like you're carrying the weight of the world on your shoulders? It is no wonder because the neck, shoulders, and upper back all seem to be settling areas for tension and likely spots for strain.

## Exercises for the Shoulders and Upper Back

● ★ Stand with the small of your back flat against the wall—your knees will be slightly bent—and try to touch the wall with the back of your neck.

● Move away from the wall. Relax your arms and let them swing so that you can clasp them first in front of your body and then behind. Repeat ten times.

● ★ Arms relaxed at your sides, tense your shoulders up towards your ears as tight as you can, then let them fall into a relaxed natural position.

● ★ Raise your chest and squeeze the shoulder blades back together as hard as you can. Relax. Repeat.

● ★ Stand in a doorway with your back pressed firmly against the doorjamb. With knees slightly bent, bend your elbows, lift your arms over your head, and grasp the doorjamb behind your head. Now spread your elbows as far as possible. Hold. Repeat.

★ Sit in a chair, grip both sides of the seat, and try to lift your bottom off the chair. Hold for six seconds. Relax. Repeat.

★ Face a wall, standing very close to it. Put both hands on the wall and try to push yourself away from it with your arms as you use your body to prevent any movement. Press as hard as you can for six seconds. Relax. Repeat.

● When you walk through a doorway, reach up and try to touch the top of the doorway.

★ When you walk through a doorway, stop briefly, push your hands against both sides of the doorjamb, and try as hard as you can to widen the doorway. Relax and walk through.

★ Stand with your back to a wall, your elbows against the wall, and attempt to push yourself away with your elbows, using your body weight to prevent any movement. Relax. Repeat.

★ Stand a slight distance away from a wall with your back to it. Hold your head back in a straight line, keep your feet slightly apart, and press the palms of your hands against the wall. Raise your rib cage and press the palms of your hands as hard as you can against the wall. Relax. Repeat.

● ★ If you are tall enough, reach up and grab the molding of the door with your fingers and then, holding on, continue to walk just past the door. Feel the stretch in your shoulders and upper back. Now grab the top of the doorway, hold on as tight as you can with your fingers, pull down, and hold. Relax. Release.

● ★ Sit or stand, extend your arms to full length, about shoulder width apart, and place the palms of your hands flat on a tabletop. Press down as hard as possible on the table with both hands. This can be done using one arm at a time, while you face or have either side of your body to the table.

● ★ If you are tall enough, place your hands up on the top of the doorway and press it as hard as you can. Hold for six seconds. Relax. Repeat. This is the equivalent of lifting a barbell.

● Lift your arm over your head so that your elbow is bent and makes a point above your head. "Scratch" your back. Alternate sides.

● With your elbow in a point above your head as in the last exercise, reach the opposite hand up and gently pull down on your elbow to get an additional stretch in the upper back and shoulder. Alternate and repeat.

● Lace your fingers behind your back and raise your hands, letting your elbows lock.

● Lace your fingers in front of you, turn your palms inside out, and lock your elbows. Lift your arms over your head and press your palms toward the ceiling.

● Lace your fingers in front of you, turn your hands inside out, and lock your elbows. Do small shoulder circles backward and forward, do half circles to the back and to the front, and alternately lift and lower the shoulders.

● ★ Shrug and relax. Repeat.

● Sit on the floor with your legs straight ahead and your hands behind you, palms down, about shoulder width apart. Slowly move the buttocks and legs forward, keeping the palms of your hands fixed on the floor behind you until you can feel the stretch in front of your shoulders. Keeping shoulders relaxed and down, hold the stretch as long as comfortably possible.

*T*urn the park bench into a "bench press" when you push into it with your foot and lean into the back with force. For the upper body, clasp your hands behind your head and pull forward while resisting with your head and neck.

• Stand in a doorway, grab the frame at shoulder height, and then gradually lean your torso forward until your arms are at a full stretch. Slowly walk forward until legs and trunk are vertical. Hold this stretch as long as comfortably possible.

• Lie on your stomach, bend your elbows in front of you so that you can cup your chin in your hands, and gently stretch your head backward as far as possible so that you are stretching and lifting the neck and upper body as you try to pull your shoulders and upper back toward your lower back. Movement will be minimal but you will feel the stretch in your upper back.

• Reach across your chest with one hand and grasp the big muscle at the top of the opposite shoulder. Using your fingertips to find the tightest part of the shoulder, firmly grasp the area and continue to knead for at least thirty seconds or until you can feel the heat. Put your fingertips on your shoulders and rotate the elbows backward in a big circle, pause, then rotate the elbows in the opposite direction. Repeat.

• Lace your fingers behind your back and pull your shoulder blades together by lifting and stretching your arms upward. Drop your arms and slump forward. Repeat.

• Lace your fingers behind your head, bring your elbows together, bend your head forward, and round your back. Pull your head down and let it gently "bounce."

• Bend your arms as you lift them higher than your shoulders and let your palms face out in front of your chest. Lift your elbows higher than your shoulders, stretching them up over your head and as far back as possible.

• Place your right hand between your shoulder blades. Then place your left hand on your right elbow (which is pointing up). Press down with your left hand and hold. Repeat on the other side.

• ★ With palms facing each other, place the edges of your hands on a table- or countertop. Press your elbows down at your sides while you keep your head and chest high, and press the edges of your hands firmly down on the table. Now drop your arms loosely down at your sides, maintaining the erect posture.

• ★ Cup the back of your head with one hand, keeping the elbow high in front of you. Push the back of your head against the hand while pulling up on your head with the hand. Repeat with the other arm. You can do this anyplace; just pretend to be fixing your hair.

• Swing your arms in opposite directions: left arm up, right arm back and then reverse the action. Do a couple of tiny little bounces with each movement.

• ★ Stand or sit up straight with your fingertips on your shoulders and your elbows out to the sides. Bring elbows together in front of you, bend over, then swing them back behind you as far as they go. To add a chest-toning step, tense the chest muscles and resist as you bring the elbows together in front of you. Repeat.

• ★ Bend your elbows and, keeping them close to your body, pull them back as far as possible.

• ★ Hug yourself, holding your right shoulder with

your left hand and your left shoulder with your right hand. Pull as hard as you can both to stretch and tone the upper back and to firm the chest and arms.

• Massage your shoulders by placing your right hand on your left shoulder and your left hand on your right shoulder. Keeping your shoulders relaxed and your elbows close to the front of your body, press firmly on your shoulder muscles and slowly roll your head from left to right and back to front.

• ★ Bring your upper arm across your chest so that your forearm goes over your shoulder; using the opposite hand, gently push the elbow back. Resistance adds to the strengthening of the stretch.

• ★ Clasp your hands low behind your back and extend one leg out to your side. Pull the arm on the same side as the extended leg out of the way so that you can turn your head to look at your heel. The shoulder of the arm you are pulling will dip down.

• ★ Turn to the right and grab the back of your chair with both hands. Hold. Turn to the left, grab, hold, and repeat.

# The Arms and Chest

Are your arms bareable? Is your chest something to pin a medal on? If not, here are some sneaky exercises that can get and keep your upper body in the shape it's meant to be in.

### Exercises for the Arms and Chest

★ Grasp the armrests of your chair. Make sure your weight will be evenly distributed and lift your body off the chair, keeping your knees together.

★ Push against a wall as hard as you can, resisting with your chest muscles.

★ Pick up a towel and pretend to wring it out.

★ Lay the heels of your hands flat against the edge of a desk, and push hard, tensing the muscles of the chest.

★ Stand with your arms down and in front of you with the backs of your hands touching. Keep the arms and shoulders forward and twist your arms until palms face outward and your little fingers touch

each other. Twist your arms again so the backs touch again. Repeat several times.

★ Stand with your feet apart and your hands clasped behind your back. Lift your chest and pull your hands down toward the floor so you bend backwards. As you do this, lift your chest even higher.

● Clasp your hands behind your head and pull it down to your chest. Slowly raise your head and spread your elbows wide apart.

● ★ ■ Take a deep breath as you lift and expand your rib cage. Exhale.

★ Press each hand into the crook of the opposite elbow, hold on tight, and without letting go try to pull your arms apart.

★ Clasp your hands close to your body at chest level and press them against each other as hard as you can.

*R esisting the push/pull of the train's stops and starts with a little help from the hand grip can release end-of-the-day tensions, as well as strengthen arms and chest. Also, a simple turn of the head from side-to-side is an excellent way to loosen up tight neck muscles.*

• ★ Stretch both arms out in front of you at chest level with the backs of your hands touching. Press them against each other as hard as you can.

• ★ Standing with your arms at your sides, stretch your fingertips down your thighs as far as possible, and then press your arms and hands against your body as hard as you can.

★ Press the palms of your hands together in front of your chest as hard as possible.

• ★ Holding a belt, towel, sweater, or scarf, extend your arms straight up over your head and pull the item outward as tight as possible, then back as far as possible.

• ■ Swing your arms while walking at a good clip.

• ★ Sit upright in a chair and grip the seat. Try to shrug your shoulders as you pull your arms down.

★ Stand in front of the edge of an open door, feet slightly apart, with the palms of your hands on either side of the door edge, fingers pointing upward. Lift your elbows out wide to either side until your forearms are parallel to the floor and your upper and lower arms form right angles. A) Press your hands together as strongly as possible as if you were trying to bring the palms together. B) Put the palms of your hands together over your head, elbows slightly bent, and press the palms together as hard as you can. C) Stand in a doorway and press the sides of your fists against the doorjamb.

• ★ Standing with your back to a wall, reach back over your shoulders and press your palms against the wall as hard as possible.

• ★ If you are tall enough, stand in a doorway and stretch your arms overhead in the door frame. Your arms may be bent, but attempt to straighten them.

★ Sit down, place your hands under a table or desk, and try to press your hands up.

★ Sit down, place your hands on top of the table, and try to press down.

★ Sit down, extend your arms on a tabletop, and try to press your hands and arms down.

★ Bend your arms at the elbow in front of you and

forcibly press your left fist against your right palm. Repeat with your right fist in your left palm.

★ Lie on your back and hold a weight in each hand about three inches above your chest; your arms should be folded and shoulder width apart. Extend the arms overhead, exhaling as you lock the elbows. Inhale and pull the arms back down. Now, keeping the weights in each hand, make a circle with your arms as though you were hugging a friend. Inhale, outstretch your arms and tense your chest muscles, keeping your arms rounded throughout. Exhale and return to the starting position.

● Stand with your hands clasped behind your back and feet a little bit apart. Slowly bend as far down as you can while bringing the arms up.

★ When you go through a doorway with your hands at your sides, place the palms of your hands on the outside of the frame so that you can press your palms back and push yourself through the threshhold. Do this same exercise with your arms at shoulder height.

● ★ Hold a scarf or belt in your right hand. Bring your hand up over your head, and let one end of the item fall behind your back. Bend your other hand across your back at waist level and grab the bottom of the belt. Pull tightly, trying to extend your arms in opposite directions. Repeat on the other side.

● ★ Do the previous exercise, but this time alternately let one arm be stronger so that you feel a good stretch.

★ Bend your elbows in front of you and grab your right wrist with your left hand and your left wrist with your right hand, and try to pull them apart as you resist.

★ Keep your arms in the same position, but this time one palm should face up and the other should face down. Now alternately try to press upward with the right hand and down with the left, then up with the left and down with the right, holding on to your wrists all the while.

● ★ Hold a weight in your hand, stretch your arm in front of you with your elbows locked, and raise your arm in front of you as high as you can. Slowly lower your arm. Alternate sides.

• Sit in a chair, place the palms of your hands on the seat of the chair, point your fingertips backwards, and straighten your arms as much as possible.

• Lace your fingers together and extend your arms in front of you, palms out, as far as you can.

• Lace your fingers in front of you, turn your palms inside out, and lock your elbows. Lift your arms over your head and press your palms toward the ceiling.

★ Sit down, place your palms on a chair seat, and push down as hard as possible.

★ Sit down, grab the seat of the chair with your hands, and try to lift the chair off the floor. Tighten your chest muscles.

★ Stand, bend your elbows at your waist and, as hard as you can, press your elbows against your sides.

★ Stand with your back against the wall with your arms in close to your sides and bent at the elbows. Press your elbows against the wall as hard as you can.

★ Sit at a table, make fists, and place them under the

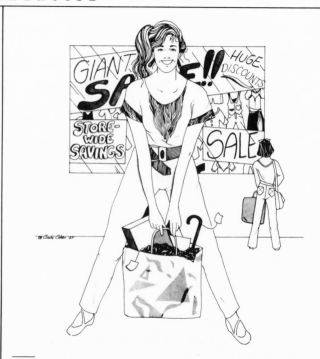

**W**eightlifting shopping bags all the way home from a big sale has its own reward: you'll look that much more terrific in everything you've just bought.

table, thumb side up. Try to lift the table with your fists.

★ Sit at a table, place the backs of your hands under the table, and try to lift.

★ Sit at a table, place the palms of your hands under the table, and try to lift.

★ Sit in a chair, place your left hand in your lap, palm side up. Place your right hand in your left. Try to bend your left arm at the wrist and elbow, but use the right hand to resist the movement. Now place your right hand in your lap and repeat the exercise.

★ Sit in a chair, place your left hand in your lap, palm side up, and with it grab your right forearm just below the elbow. Try to bend the left elbow up, but prevent it with pressure from the right arm. Now place your right hand in your lap and repeat the exercise.

★ Sit in a chair and place both hands under your thighs. Try to lift your legs but resist with your leg and chest muscles.

★ Stand and hold a weight in your right hand. Keep your arm close to your side and lift the weight by bending at the elbow. Repeat with the left arm.

★ Stand and hold a weight in your right hand. Raise your right arm out to the side, keeping your elbow locked. Repeat with the left arm.

★ Stand and hold a weight in your right hand. With your arm at your side, palm facing forward and elbow locked, slowly lift your arm up until your nose touches your biceps. Repeat with the left arm.

★ Stand and hold a weight in your right hand at shoulder level and raise it overhead; slowly lower the arm again. Repeat with the left arm.

★ Stand and hold a weight in your right hand. Keep your elbow locked and lift your arm behind you. Repeat with the left arm.

★ Stand and hold a weight in your right hand. Keep your elbow locked, bring your arm out to the side, and make a slow circle. Repeat with the other arm.

★ Hold books or any other weight in both hands.

  1. Lift them over your head.
  2. Lift them out in front of you.

3. With elbows bent into your sides, lift them with your forearms toward your shoulders.
4. With arms straight out at shoulder height, lift them to your shoulders with your forearms.

● ★ Hold an umbrella with both hands in front of your thighs in an underhand grip. Bring the umbrella up to your shoulders as in an arm curl and return to the starting position. Repeat.

★ Stand and, with palms facing inward and arms extended straight down, hold weights in front of your thighs. Pull the weights upward as high under your chin as possible, keeping the elbows pointing down. Lower and repeat.

★ Stand straight and hold one weight overhead with your arms extended and both hands clasped around the weight. Lower the weight behind your head, keeping both elbows close together and trying to point elbows at the ceiling. Repeat.

★ Stand straight—do the tuck—and with feet apart, hold weights in each hand. Let your arms hang naturally at your sides. Without bending the arms, shrug your shoulders upward as far as possible, trying to touch your shoulders to your ears. Relax. Repeat.

★ Sit down, and with palms facing down, hold a weight in both hands at arms length in front. Slowly lift the weight as high overhead as you can and then lower it as far down behind you as possible. Lift it high again and bring your arms back to the starting position.

★ With legs slightly apart and weights in both hands, extend your arms to shoulder height and, with palms facing down, draw small circles in the air with your fingertips. Keep your torso still. Circle forward first, then backward. (Note: It is very important to use the tuck to support your back whenever doing work with weights. It is the great injury preventor!)

● ★ Place your hands under the car bumper. Bend your knees and try to lift the car. Now place your hands on the car hood and try to push the car down the road.

★ Face your desk or chair and stand at a distance away from it. Lean forward and put your hands on the

desk or the arms of the chair, keeping your arms at a right angle to your body. Shift your weight forward onto your arms, then raise and lower your chest in a push-up-like manner. Repeat.

# The Abdomen, the Back, and Posture

Tuck away the pot belly, backache, and slouch in your posture. It is impossible to separate the exercises necessary to firm your abdominals from those that condition your back and create good posture. You don't have to be fat to have a pot belly, nor is it only a traumatic injury that will throw your back out. You might even be an exercise enthusiast who jogs, swims, bikes, and plays three sets of tennis on Sunday—*with* a bulging belly. All it takes is weak abdominals.

## Exercises for the Abdomen and Back

★ Create the "C" shape. With your knees slightly bent and your shoulders relaxed, lift your torso (rib cage),

pull your abdominals in and up, and gently squeeze the muscle of your buttocks under. Before long you will find a "hollow" where your tummy was.

● ★ Frequently, whenever you can, lift the torso and, press the small of your back against walls, chair backs, the headboard of your bed, or other flat, vertical surfaces.

● ★ ■ When carrying packages or shoulder bags, try to switch from one side to the other so that you aren't always walking with one shoulder higher or lower than the other.

● ★ To ease pressure on your back, sit with your feet flat, drop your head forward, and let your arms dangle between your knees. Contract your abdominals, tuck your buttocks under, and roll forward one vertebrae at a time as you return to a standing position. Picking something up off the floor is a good excuse to do this exercise.

● ★ Take the possibility of injury out of lifting things by bending your knees, bringing the object close to your body, and lifting it by straightening the knees

and using thigh muscles to pull up. This way you are both stretching and toning the entire body, instead of straining your back.

• If you have to stand on your feet for long periods of time, try to find something to put one foot on so it's slightly off the floor. When you do this, you straighten muscles. Alternate feet and you will find that back strain is reduced. To relieve tension in your back, it is often good to go through a total body relaxation by taking a deep breath, exhaling slowly and completely through your mouth as you tighten individually every muscle in your body. Continue to breathe deeply. Teach your body to be aware of the difference between tension and relaxation.

• Sit in a chair, put your knees together, and, twisting your body, slowly lower your torso so that your right hand is on the floor and your head is down. This is a good stretch for the lower back. Tuck the abdominals and roll back up. Twist in the other direction so that you stretch the muscles on the opposite side of the back.

• ★ Stand, and with your feet together, bend your knees, reach down, and touch your hands to the outsides of your feet. Keep your buttocks down, your head tucked into your chest, and use the abdominal muscles to roll yourself up to an upright position one vertebra at a time. When the body is upright, press your shoulder blades together and raise the head to its natural position.

• ★ Sit at the edge of a straight-backed chair with your feet resting flat on the floor and your hands on your knees. Lift your torso and abdominals and roll your lower back, pulling your stomach in as you do.

• ★ Sit on the floor and press your back flatly against a wall with your knees bent and your feet on the floor. Tuck your stomach in and up at the same time as you press your back firmly against the wall.

★ Stand with your back against the doorjamb, feet slightly apart, hands behind you holding on at about hip level. Bend your knees slightly and slide down the wall so that you're almost in a sitting position.

*M*ake being a spectator into a sport with all kinds of sneaky exercise. Jump, twist, reach, stretch—the energy you generate will be contagious!

Press back with the small of your back. Now, slowly slide up, keeping the small of your back against the wall and straightening your knees.

● Stand erect, feet shoulder-width apart, and slowly bend forward at the waist, letting your arms, shoulders, and back relax. If it is not a strain for you, continue down and pick something up off the floor.

● ★ Stand with your feet apart, knees slightly bent, hands just above your knees. Lift the torso and round the back by pulling the abdominals in and up. Relax. Repeat. From this position, push your knees straight by leaning your hands on them and straightening the elbows; at the same time lift your head and flatten your back until your torso is at a right angle to your straightened legs.

● ★ Sit on the floor with feet flat and hands on your bent knees. Lift your torso, tuck your tummy up and back, and roll your lower back toward the floor. Try to make a circle with your body.

● ★ Inhale as deeply as you can and then exhale completely. As soon as you've gotten all the air out of your lungs, pull your stomach in and up until you feel as though it's pressing against your backbone. Hold for six counts. Release.

● ★ Sit up as straight as you can and at the same time pull your stomach in and up, squeezing the buttocks under.

● ★ Stand with your knees slightly bent and your hands resting on top of your knees. Contract the abdominal muscles, pulling your stomach in and up as hard as you can.

● ★ Stand with your knees slightly bent, your feet a little apart, and your hands on your hips. Lift the torso, pull the abdomen up and in, and squeeze the buttocks forward. Relax. Repeat ten times.

● ★ Hold the last tuck and with torso lifted, twist your rib cage from side to side, holding the rest of your body still.

● ★ Sit in a chair with your feet flat on the floor and lift your torso, pulling the abdomen in and up. Raise one knee toward your chest, grab it with laced fingers, and pull it back toward your chest. Lower the leg. Repeat with the other leg.

● ★ Grip the chair you are sitting in, tuck, and lift one leg just slightly off the floor. Lower it. Tuck again, and lift the other leg just slightly off the floor. Lower it. Tuck again, and lift both legs slightly off the floor. Lower them. Repeat.

● To relieve lower back soreness, make fists and place the backs of your hands as high on your back as you can reach. Briskly rub the muscles on either side of the spine, moving your fists all the way down to the lower buttocks and then massaging up again as far as you can reach, which should be about mid-back.

● ★ Sit or stand, tuck, and then twist your torso from side to side.

★ Lie on the floor with your feet flat and your knees in the air. Tuck and then curl your shoulders and head slightly off the floor, holding the rib cage up and the tummy in to form the "C" shape.

● ★ Tuck every time you bend, reach, twist, or lift.

● ★ Stand slightly away from a table or bureau with your hands pressing down on the top and your elbows locked. Bend your knees as you tuck the stomach up and in and round your back. Hold. Relax. Repeat.

● ★ Stand with your knees bent and your hands resting on your knees. Pull your abdomen in and up and round your lower back.

● ★ Lie on your stomach with your head resting on crossed arms. Pull your stomach off the floor as you squeeze the buttocks under, pressing the pubic bone to the floor.

● ★ ■ Lie on the floor with your feet flat, knees in the air, and hands behind your head. Lift your torso, tuck your tummy and your buttocks, and, holding the "C" shape in the stomach, lift your head and shoulders off the floor. Hold the contraction for six seconds. Relax.

## The Waist

The waist separates the ribs from the hips and the more you lift the torso, the more you will increase

the distance between the rib and hip bones, giving your entire figure the appearance of being longer, leaner and thinner. The waistline muscles turn the upper torso from side to side, and allow you to bend right, left, forward, and back. They are also the muscles that work with the diaphragm to assist in breathing. Toning these muscles will help whittle your waist.

## Exercises for the Waist

● ★ Twist and turn from the waist as much as possible while maintaining your tuck. By lifting the torso, pulling the stomach in, and squeezing the buttocks under, you can isolate the waist so that it is the only section of your body moving.

● ★ Sit or stand, tuck, let your arms hang loosely at your sides, and reach down as far as you can to the right. Straighten up, then reach down as far as you can to the left. Straighten up. Repeat.

● ★ Stand or sit with your hands at your waist and elbows out to the side. Extend your left arm, and reach as far as you can to the left. Straighten up. Extend your right arm, and reach as far as you can to the right. Straighten up. Repeat.

● ★ Stand or sit with your fingers laced behind your head and your elbows out to the side. Reach as far to the left, then to the right, as possible.

● ★ Hold an umbrella or scarf high overhead, lock your elbows, and lean from side to side. A golf club or tennis racket or any other object would be great to assist in this stretch.

● ★ Sit with your legs slightly apart. Tuck, bend from the waist, and touch your left foot. Hold. Then switch to your right foot. Hold. Repeat.

● ★ Lace your fingers, turn your palms inside out, and press them toward the ceiling. Press your arms backward as far as possible. Lean the torso first to the right and then to the left, stretching as far as you can in each direction.

● ★ Try to reach for things on the highest shelf. Stretch first with your right hand, then with your left (even if what you want is not on the highest shelf).

● ★ Instead of taking a step backward to see behind

you, twist around with your upper body, first to one side and then to the other.

• ★ Try to arch, twist, and stretch the waist as often and in as many ways as possible.

• ★ Stand with your feet apart and hold an umbrella, broomstick, or other straight object that you've rested on your shoulders. Bend the body to the left side as far as possible, then straighten up. Bend to the opposite side as far as possible. Straighten up. Repeat.

• ★ Sit up very straight on the floor and cross your legs. Lower your chest toward one knee, then straighten up. Lower your chest toward the other knee, then straighten up. Repeat.

• ★ Sit with your legs apart and your hands on your hips. Tuck, keeping your back straight, and bend first to the right side and then to the left.

• ★ Sit on a chair, cross your right leg over your left leg. Bend forward slightly and place your straight right arm against the inside of your right leg with your elbow inside your knee. Let your left arm reach behind your back to the right and stretch from the shoulder as far as you can comfortably go. Now cross your left leg over your right and stretch to the left. (But don't make leg-crossing a habit—there is evidence that this contributes to varicose veins.)

• ★ Sit at a desk, place the left hand on the back of your chair and the right one on the desk. Twist your body as far to the left as you can. Switch arms and twist to the other side.

# The Buttocks

Buns are in, and I don't mean the kind you have with hamburgers. The good news is that it does not take much to firm and lift this part of the body or for others to notice the results.

### Exercises for the Buttocks

★ Anywhere and at any time, tighten and release the buttocks muscles.

★ Sit in a chair and lift your right buttocks off the seat.

Hold for six counts. Relax. Lift the left. Relax. Repeat.

★ Sit in a chair, flex the buttocks muscles in and out so that you bounce slightly. Do this as fast as you can for as long as you can.

★ Lie on your stomach on the floor with your head resting on your forearms. Tighten and just barely lift one leg off the floor as you press your hip bone into the floor by squeezing the buttocks.

★ Sit all the way back in a chair with your legs slightly apart. Lift the right hip and move it forward. Now inch forward with the left hip. Alternate until you're sitting on the edge of your seat. Inch to the back of the chair in the same manner.

★ Sit up straight with feet flat and arms at your sides. Tighten the buttocks. Raise your chest and straighten your spine as tightly as you can. Relax. Repeat.

★ Stand with your feet together and squeeze your buttocks and tighten your abdomen as you raise your

**K**icking back slightly while tightening the buttocks will result in "bottoms up."

leg slightly behind you. Although it is not necessary to lift your leg more than a few inches off the floor, you still may feel more balanced if you are holding on to something when you do this exercise. As you get better at it, alternate the movement by drawing tiny circles in the air with your heel when your leg is extended to the back.

★ Stand with your hand resting on a support at about waist height and bend your knee at a right angle. Tighten the buttocks and gently pulse the leg back and forth—keeping the knee bent—then return to a natural position. Repeat with the other leg.

★ Stand on one leg and, holding onto a support with one hand, bend the other knee so that the other foot is directly behind you. Bend the knee of the leg you were standing on and, as slowly as you can, tucking under as you do, bend and straighten the knee. Repeat with the other leg.

★ Lie on your stomach with your upper body propped up on your elbows and hips pressed down into the floor by squeezing the buttocks. Bend your left knee a little and do twenty tiny leg lifts, raising the thigh as high as possible without raising the hip. Repeat with the other leg.

★ In the same position, do twenty leg lifts with a straight leg, keeping the hip pressed into the floor. Repeat with the other leg.

● ★ Squeeze the buttocks and do tiny lunges. Stand, hold on to a support, and bend your left knee so that the foot is directly behind you. Do tiny kicks back and squeeze the buttocks. In the same position, squeeze the buttocks, bring your leg back as far as you can, and hold for the count of six. Relax. Repeat both steps on the other side.

● ★ Bend your body at the waist and lean your elbows and forearms on a table, desk, or chair back. Bend one knee so that one foot is directly behind you at thigh level. Do tiny leg lifts and squeeze the buttocks. Repeat on the other side.

● ★ Stand with one side to a wall. Lift the other leg up from the hip and move the leg forward and back, tucking the tummy tight as you move it forward, squeezing the buttocks tight as you move it back.

You should not get much swing with the leg because you'll be controlling it from the abdomen and buttock muscles. You will, however, be getting a tremendous toning in the abdomen and buttocks.

★ Stand with your right hand resting on a table. Bring your left leg out to the side and flex your foot. Tighten the buttocks and make tiny kicks out to the side. Do the same on the other side. Remember that, because you are holding the buttocks muscles so tight and you are lifting and tucking the abdominal muscles so hard, you do not get a large motion with these exercises. The leg barely moves at all because the tension in the muscle is resisting the movement.

★ Lie on your back with your elbows bent at right angles. Tighten your hips and buttocks as you tuck so that you are slowly raising the buttocks off the floor just a bit. Remember again that, because you are tucking down with your stomach, you will only get a slight rolling of the buttocks and hips. The toning, however, is tremendous.

★ Stand with your back to a wall and press your right leg against the wall as hard as you can. Keep your legs straight and your buttocks tight. Repeat with the other leg.

★ Kneel and sit back on your heels. Tuck so that you are rolling your buttom off your heels. Hold for six seconds. Repeat.

# The Legs

Considering that your legs are half the length of your body, the exercises in this section must fill a tall order. However, do them consistently and you will soon develop jiggle-free thighs and legs, worthy of showing off.

### Exercises for the Legs

● ★ ■ Walk, walk walk! See the aerobics section for more on this wonder exercise.

★ Tuck, press your lower back against a wall or flat surface, and cross your arms in front of you. Slowly bend your knees and slide yourself into a seated

position—your bottom should stay above knee level. Hold until you feel a tingle in your thighs.

★ Make the exercise above a calf workout by lifting your heels and standing on the balls of your feet while you do it.

★ Stand next to a wall, extend your left leg forward, and slowly bend your right knee so that you are squatting slightly. Hold. Return to the starting position. Repeat on the other side.

★ Sit with your legs extended and press down on a raised object, such as a box, stool, or the edge of a wastebasket.

★ Sit on the floor with your feet crossed at the ankles while holding the ankles tightly together. Try to pull your legs apart.

★ Sit on the floor with your legs extended and feet up straight. Try to get your toes to point toward your body; pull the balls of your feet back as hard as you can. Hold. Now point your toes and try to touch a spot on the floor just beyond your big toe, but don't move your hips.

*A**dding weight to your walk builds your body from all angles. Make sure the weight is evenly distributed.*

★ Sitting, flex the right foot, raise it slightly, and loop a belt around the sole. Pull it taut and attempt to straighten that leg but prevent it from doing so by pulling back with the belt. Hold. Repeat with other leg. Try to point your foot but prevent yourself from doing so by pulling the belt. Now lift the leg straight out in front, squeeze it tightly, and just hold. Relax. Repeat with the other leg.

★ In a seated position, cross the right leg over the left and squeeze the two together as hard as possible. Hold. Repeat on other side.

★ Sit on the floor with your legs extended and your hands just behind you for balance. Squeeze your legs together as hard as possible. Hold. Relax. Repeat.

★ Sit and put one leg on top of the other. Try to lift the bottom leg while pushing down with the top. Switch legs. Repeat.

★ Sit cross-legged and rest your hands on top of your knees. Try to lift your knees while you resist with the pressure from your hands. Hold. Relax. Repeat.

★ ■ In a seated position, march your feet in place.

Stand with your back about eighteen inches from a wall and place your right foot flat against it. Push back with your heel as hard as you can. Hold. Relax. Repeat with the other leg.

★ Stand with your left side to the wall and press your left foot against it as hard as you can. Hold. Relax. Do the same thing on the other side.

★ Stand with your back to the wall and place your right foot flat against it. Push back as hard as you can. Hold. Relax. Repeat with the other leg.

● ★ If you are tall enough, stand in a doorway and reach up so that you are holding the top of the door-frame with your palms. Now press up as hard as you can, standing on your tiptoes if necessary.

● ★ Stand or sit, tuck, and raise one knee as high as possible toward your chest, grabbing it around your knee with laced fingers. Hold. Relax. Repeat on other side.

● Squat and place your palms flat on the floor. Keeping your hands down, try to straighten your knees.

- Sit on the floor with your legs wide apart and place your palms on the floor in front of you. Bend from the elbows and relax the body forward. Hold. Sit upright. Repeat.

- Sit forward on the edge of your chair with both legs fully extended in front of you. Let your body drop forward toward your feet. Hold. Sit upright. Repeat.

- Stand and put your right foot up on a piece of furniture. Keep your left foot flat, the left knee locked, and try to stand as close to the piece of furniture as possible.

- ★ Sit straight in your chair, raise your right leg so that it is parallel to the floor, flex your foot, and hold. Now make tiny bounces up and down with the leg, keeping the knee locked. Relax. Do the same on the other side.

- ★ ■ Walk on tiptoes.

- ★ ■ Walk on your heels.

- ★ ■ Walk pigeon-toed.

- ★ ■ Walk duck-footed.

- ★ ■ Stand on your tiptoes.

- Bend from the waist, and reach down to touch the floor or to pick something up.

★ Stand on one foot as long as you can. Relax. Do the same on the other side.

★ Stand on one foot and lift the other foot to tie your shoe or straighten your sock. Do the same on the other side.

- ★ ■ Walk up stairs as often as possible. (Going down stairs may seem easier, but it's tougher on your knees and you don't get the aerobic benefit.)

- ★ Stand on your toes, and bend your knees just slightly as you tuck the buttocks under into a half knee-bend. Hold. Relax. Repeat.

- ★ Stretch one leg out in front of you as far as you can and hold. Relax. Repeat with the other leg.

- Stand, bend your right knee behind you, and lift your foot with your right hand. Hold. Relax. Repeat with the other leg.

★ Sit, raise your right foot, and hook it behind your lower left leg. Try to straighten your right leg but resist with the left. Hold. Relax. Repeat with the other leg.

★ Sit with your feet crossed at the ankles and try to push the back foot forward while you resist with the front foot.

● Try at least once a day to bend your knees so that you are squatting with your bottom on your heels.

● ★ Sit with one leg crossed over the other and try to pull your foot in toward your body with your hands. Switch sides.

● Stand with both feet flat and one foot in front of the other. Bend the forward knee as you push into a wall, car, or any immovable object.

● Stand about three feet from a wall, and lean forward against it. Keep your body straight, knees locked, and place your palms against the wall at eye level. Step back away from the wall but continue to support your weight with your hands. Keep your feet flat.

● ★ Stand and take a giant step forward with one foot. Bend the forward knee. Hold the stretch. Relax. Repeat with the other leg.

★ Sit, stand, or lie down, keeping one knee bent and the other knee locked. Raise (slightly) the locked knee as many times as you can, feeling the tightening in the quadricep. Repeat on other side. This will help strengthen your knees against injury and can help repair damage that has occurred.

★ Forcibly straighten one knee while relaxing the other. Alternate.

● ★ Lift your foot off the ground by pulling your hip up into your body. Alternate sides.

★ When getting out of a chair, don't use your hands to assist you. Instead, use the large thigh muscles and your abdominal muscles.

● ★ Hug one or both knees to your chest while sitting or standing.

● Shake your leg loosely for a couple of seconds. Repeat on other side.

● ★ Alternately contract the thigh muscles of your right leg and the thigh muscles of your left leg for three seconds each.

● ★ Alternately contract the calf muscles of your right leg and the calf muscles of your left leg for three seconds each.

● ★ Alternately contract right thigh muscle and left thigh muscle, right calf muscle and left calf muscle for three seconds each. Repeat the round. Relax. These exercises are great for toning the muscles and for increasing circulation to the legs.

★ Frequently do tiny squats by lifting the chest, tucking buttocks, pulling the stomach in, and just standing with your knees slightly bent. Hold as long as you can. Relax. You can do this when standing. If necessary, hold on to an object for balance.

★ While sitting, raise one leg to hip level, holding the foot out in front of you. Do tiny bounces. Make tiny circles with the leg in one direction and then the other. Relax. Repeat with the other leg.

★ Whenever possible, place something between your knees, such as a briefcase, and squeeze your legs together as hard as possible.

● ★ Stand with your back to a chair and bend your right knee, placing your right foot on a chair behind you. Tuck to anchor your back. Lift your legs and do tiny little flutter kicks in front of you. Relax.

★ Sit and cross your left ankle over your right with your feet on the floor and your legs bent at ninety-degree angles. Try with all your might to straighten your right leg while resisting the push with your left. Switch sides.

★ Sit and extend your legs so that each ankle presses against the outside of another chair's legs. Keep your legs straight and try to pull them together, although the object you are pressing against will make it impossible. Hold. Relax.

★ Do the same as above but this time have your feet inside the legs of the chair so that you are trying to push your legs apart. Hold. Relax.

● ★ Use the side of a car to stretch and tone by pushing against it with all your might.

★ Sit at the edge of your chair with feet flat and knees apart and at right angles. Put your elbow inside one thigh and your palm inside the other, forming a triangle with your forearm and thighs. Try to press your thighs together although your arm will not let them close.

● ★ Bend from the waist and bend from the knees.

● Take time to put your feet up on your desk so that you can relax your legs.

★ You can also place your feet up on your desk to tone your legs. Cross one ankle over the other with legs fully extended. Tuck, raise both legs, and hold for six counts. Relax. Cross ankles the other way and repeat.

★ Sit at the edge of your chair with your palms resting on your thighs and your feet flat. Raise heels off the floor and then lower them, alternating feet.

★ Sit at a desk and push one knee up against the desk as if you were trying to lift it although the desk won't let you. Hold. Release. Do the other side. Now try to lift the desk with both knees at the same time.

*A dark theater and a good movie are guaranteed to let you squeeze in a two-hour workout while friends fill up on popcorn and soda. This theatergoer is pulling back on her leg with clasped hands while she pushes out against her hands with her leg.*

★ With your baby up on your shoulders and your feet about shoulder distance apart, do some half squats.

● ★ Stand with your feet firmly on the floor, knees slightly bent, and feet about sixteen inches apart. Move your knees as close together as you can without moving your feet. Relax. Repeat.

● ★ ■ Run, jump, hop, and skip as much and as often as possible.

● ★ ■ Dance to your heart's content. Any kind is wonderful exercise.

● Stand pigeon-toed and roll your weight to the outside of your feet.

★ When standing, tighten the buttocks and leg muscles and do tiny leg kicks, first to the front, then to the side, and then to the back.

★ Sit on the floor cross-legged. Place your hands under your knees. With your hands, try to pull your knees together, but at the same time press down with your knees to resist the movement. Hold. Relax. Repeat.

★ Sit in a cross-legged position on the floor with your hands on top of your knees. Try to pull your knees together but use your hands to resist any movement. Hold. Relax. Repeat.

★ Sit on the floor with your knees bent and your feet flat on the floor. Press your knees together but use your hands to try to pry them apart. Hold. Relax. Repeat.

★ Kneel on the floor and sit on your heels. Rest your hands just above your knees. Now do tucks so that you are just squeezing the buttocks and rotating them off your heels.

★ Sit in a chair about ten inches in front of the wall. Put one foot on the wall and try to push yourself away by attempting to straighten your knee although there will be no movement. Hold. Relax.

● ★ ■ Bike riding is incredibly good for you. Pedal to your legs' and your heart's content.

● ★ Stand with your feet hip distance apart. Keep your back straight and bend forward from the hip. Hold. Relax.

# The Feet

How do you treat your feet? Do you do things that are good for your sole? Each foot is composed of twenty-six bones and their associated joints, muscles, and ligaments. Why ruin such intricate architecture by wearing an ill-fitting pair of shoes? Shoes that are too tight and rub your feet the wrong way can make blisters, bunions, callouses, and corns spring up in no time. High heels thrust your body forward, putting tremendous pressure on the forefoot and disturbing the alignment of your entire body. The exercises in this chapter will increase the circulation, strength, and stamina of the feet. Undeniably, if your feet hurt, you are miserable, regardless of the condition of the rest of your body. So start taking the right steps—right now!

### Exercises for the Feet

● ★ Sit on the edge of your chair with one leg crossed over the other. Make wide circles with your foot, rotating from the ankle for a period of time. Reverse direction. Switch legs.

● ★ When you are walking up stairs, let your heels hang lower than the step, and then push up onto your toes as you raise to the next step.

● ★ Sit with your weight forward. Lift your heels, put your feet flat; lift your toes, put your feet flat. Continue.

● ★ Stand on your toes, then roll back onto your heels, then up on your toes again and back onto your heels. Continue.

● ★ Do the previous exercise with a weight or a child sitting on your shoulders.

● ★ Raise up and down on your toes several times.

● When you come to a curb, let your heels hang off the edge of it with your toes pointing up. Hold for a number of seconds.

● ★ Put a thick book on the floor and stand on it with the front half of your foot only, letting your heels hang over the edge. Now raise and lower your toes slowly, first trying to let your heels touch the floor and then trying to stand up on your toes as tall as possible. Continue.

- Spread your toes as wide apart as possible. Hold. Relax. Repeat.

● ★ Sit, cross your right foot over your left leg, and try to write your name in script with your right toe, moving the ankle as much as possible in different directions. Switch legs. Repeat. If your name has just a few letters, write the alphabet.

● ★ Sit with your bare feet flat and parallel to each other a couple of inches apart. Try to move just your big toes toward each other to touch each other. Relax. Repeat.

● ★ With your feet pigeon-toed, stand up on your toes. Relax. Repeat.

● ★ With your toes pointed out, stand up on your toes. Relax. Repeat.

● ★ Stand with your back to a wall, the balls of your feet resting on a two-inch-thick book, and your heels resting on the floor. Without lifting your heels, roll your weight to the outsides of your feet. Hold the position as long as you can. Relax.

★ Stand with left foot on top of right foot, back erect. Hold as long as you can. Switch feet.

● ★ Point your toe as hard as you can, then flex your foot back as far as you can. Repeat. Relax.

● ★ Walk on your tiptoes.

● ★ Walk on your heels.

● Stand with one foot slightly in front of the other. Raise the toe and ball of your foot so that your weight rests on the heel; turn that foot inward and hold the position. Now turn it outward and hold. Repeat with the other foot.

● Massage your bare feet with your hands, being sure to curl the toes, bend them back, and massage your arches.

● ★ Sitting with feet flat, lift the toes off the floor and turn them inward and outward in repetition.

● ■ Sitting, raise the balls and toes of your feet and squeeze your toes under. Hold. Relax. Repeat.

● ■ Alternately stand up tall on one toe and then on the other. Continue.

# The Hands

Manicure salons are popping up everywhere. But are we really taking care of our hands? The muscles of the fingers and the hands work with those of the wrist and forearm to make miraculous motions. The design is mind-boggling. However, few of us in our everyday lives move the hands as much as we should or in as many directions as we can. Therefore, as hands grow older, we see them losing strength, flexibility, dexterity, and their youthful beauty. Through exercise you can help to keep the joints of the hands from becoming stiff and keep their movements graceful. Here are some exercises just for the hands.

### Exercises for the Hands

★ When you answer the telephone, grasp the handle tightly.

★ Before you hang up, grip the mouthpiece and earpiece and try to pull the phone apart.

★ Before you hang up, put your hands on the outsides of the mouthpiece and the earpiece and try to push them together. Hold. Relax. Both of these exercises also work with the muscles of the chest and arms.

● ★ Spread fingers and thumbs and press them down on a tabletop as hard as you can. Hold. Relax. Repeat.

★ Squeeze a small rubber ball in your hand repeatedly.

● ★ Wrap a rubber band around the fingertips and open the fingers as wide as possible. Adjust the tightness by using various sizes of rubber bands or by wrapping one around twice.

● ★ With your palms turned up, bend the fingers so that the tips of the fingers just touch the pads at the base of the fingers. Extend the fingers. Repeat.

● ★ Hold the hands together with all ten fingertips touching. Separate the thumbs and circle them around each other, first toward you and then away from you. Now separate only the index fingers and circle them around each other, first in one direc-

tion and then the other. Continue with each pair of fingers.

● ★ Open your hands as wide as you can, spreading the fingers out and stretching them. Clench the hands together as tight as you can. Repeat.

● Shake the hands vigorously and relax.

● ★ ■ Shake your hands as you do your fast-paced walking.

● ★ Standing or sitting, hold an umbrella or broom-stick in front of you with your hands about hip distance apart. With palms up, roll your wrists toward you as far as possible and then away as far as possible. Continue. Now do the same exercise, but this time hold the object with your palms facing down.

★ Sit at a table, spread your fingertips wide under the table, and try to lift as hard as you can. Hold. Relax.

● ★ With palms up and fingers extended, bring the little finger down to touch the palm and return; now bring the next finger down to touch the palm and

return. Continue with five fingers and both hands. Repeat.

● ★ Make fists as tight as you can, then spread the fingers as far as you can. Continue.

● ★ With hands out in front of you and your palms up, bend the fingers so that your fingertips touch as far down toward your wrists as possible. Extend the hands.

● ★ Move the thumbs as far away from the rest of the fingers as possible. Relax. Repeat.

● ★ With your hands flat on a table, lift and lower one finger at a time. Repeat.

★ Grip your right wrist with your left hand and squeeze as hard as possible. Relax. Repeat with the other hand.

★ Hold a weight in one hand and rest your forearm on the edge of a table with your hand hanging palm down over the edge. Raise the wrist straight up toward the ceiling as far as possible. Hold for six counts. Relax. Repeat. Repeat with the other hand.

★ In the position described in the previous exercise,

*T*ake advantage of sun-warmed muscles, and stretch!